IMAGES of America
TEXAS SHIPWRECKS

Mark Lardas

Copyright © 2016 by Mark Lardas
ISBN 978-1-4671-1617-6

Published by Arcadia Publishing
Charleston, South Carolina

Printed in the United States of America

Library of Congress Control Number: 2015953581

For all general information, please contact Arcadia Publishing:
Telephone 843-853-2070
Fax 843-853-0044
E-mail sales@arcadiapublishing.com
For customer service and orders:
Toll-Free 1-888-313-2665

Visit us on the Internet at www.arcadiapublishing.com

To my mom, Betty Lardas, for everything.
I cannot believe it took me this long to dedicate one of my books to you.

Contents

Acknowledgments		6
Introduction		7
1.	Let's Talk Shipwrecks: Five Centuries of Texas Wrecks	9
2.	Early Years: 1520–1775	19
3.	New Nations: 1776–1845	37
4.	The Civil War: 1861–1865	49
5.	Galveston's Golden Age: 1847–1900	65
6.	Texas River Wrecks: 1830–1900	77
7.	Through Two World Wars: 1901–1949	89
8.	To the Present: 1950–2015	103
9.	Exploring Texas Shipwrecks: Marine Archaeology in Texas	115
Museums		126
Bibliography		127

Acknowledgments

No book is the product of a single author. Many folks helped me as I wrote and assembled this book. Those I especially would like to note include my son, William Lardas, for accompanying me on many of my trips and doing the photography; Kevin Crisman, Glenn Greico, Donny Hamilton, and Justin Parkoff of Texas A&M's Institute for Nautical Archeology; Chase Fountain, Texas Parks and Wildlife Department photographer; Peter DeForest and Henry Wolff Jr. for their help with Pass Cavallo wrecks; Andy Hall and Tom Oertling of Texas A&M Galveston; Teena Maenza and the other folks from the Columbia Museum; Lisa Meisch and the rest of the staff at the Sam Houston Regional Library and Research Center; Cheri Smith of the Jefferson Historical Museum; Linda Turner and Billie Powers of the Texas City Museum; Jonathan Plant, director of the John E. Conner Museum at TA&MU Kingsville; Amy Borgens and Brad Jones of the Texas Historical Commission; Jan Cocatre-Zilgien for his help with the Ferris ships; and Dan Warren, who provided imagery from his expeditions.

I would also like to thank Mike Kinsella and Matt Todd, my editors at Arcadia Publishing, for their assistance. As well, I thank my wife, Janet, for her support during this project.

The following abbreviations indicate the sources of the illustrations used in this volume:

AC	Author's collection
BOEM	Bureau of Energy Management
CCMS&H	Corpus Christi Museum of Science and History
LOC	Library of Congress
NARA	National Archives
NOAA	National Oceanic and Atmospheric Administration
PKP	The Platoro, Keenon, Purvis Collection of the THC and the CCMS&H
SHRL&RC	Sam Houston Regional Library and Research Center
THC	Texas Historical Commission, Austin
TPWD	Texas Parks and Wildlife Department
UHDL	University of Houston Digital Archive Library
USACOE	United States Army Corps of Engineers
USNH&HC	United States Navy Heritage and History Command
WL	Photograph by William Lardas

INTRODUCTION

Shipwreck. The word evokes images of sunken Spanish treasure ships, their gold carpeting the sea bottom, or perhaps wreckers, deliberately luring ships aground in pursuit of salvage. The reality is less romantic, but often more interesting.

There are very few sunken treasure ships, mainly because only a small fraction of ships carried treasure, and most of those made it safely to port. (You cannot have a shipwreck unless a ship wrecks.) That is not to say it never happened. Three of the Texas shipwrecks discussed in this book were Spanish treasure ships. They were part of the annual silver *flota* sailing from Vera Cruz in Mexico to Havana, Cuba. But only those three.

Even ships that sank off Texas waters rumored to be carrying Army payrolls or bank transfers were not really treasure ships. The money might fill one strongbox. It was more often paper currency than specie. (Precious metal is heavy. Two cubic feet of gold—12 inches by 12 inches by 24 inches—weighs over a ton. Even at its historic price of $20 an ounce between 1700 and 1930, that much gold is worth $700,000, the equivalent of $420 million today—literally a king's ransom. It is easier to ship paper money.)

There are a lot of shipwrecks in Texas waters, though. The Texas coastline and offshore waters are flat, shallow, featureless, and filled with shoals. The navigable rivers (and Texas depended on river navigation in its early years), are narrow, twisting, and blanketed with sunken logs or sandbanks. Texas's weather is equally unpredictable to mariners. It is not just hurricanes and tropical storms providing hazards; storm fronts known as Blue Northers can drop temperatures 40 degrees in a few hours. Equinoctial storms can push the water in or out of shallows, stranding vessels and wrecking them. Throw warfare into the mix, and you have a seashore and sea bottom peppered with wrecks.

These wrecks define Texas history. In fact, it can be said that Texas's history started with a shipwreck. In 1528, while trying to sail to Mexico from Florida, Cabeza da Vaca was shipwrecked on Galveston Island. After eight years as a slave of local Indians and an epic hike to Santa Fe, New Mexico, he returned to Spain and wrote a book about his experiences. It was written history's first mention of what would become Texas.

Shipwrecks continued to play an important part in Texas history over the next six centuries. Sometimes shipwrecks played an obvious role. A major cause of the failure of La Salle's attempt to create a French colony in Texas was the loss of two of the three ships of his expedition. First *Amiable*, and then *la Belle*, ran aground and sank. They took with them most of the expedition's supplies and trade goods and its only means of abandoning the colony. So, while La Salle's colony gave Texas one of the six flags that flew over Texas, shipwrecks kept Texas from remaining a French possession.

Nearly two centuries later, Union attempts to capture key Confederate ports on the Texas coast were frustrated by its naval losses—and the ships sunk—at the battles of Galveston and Sabine Pass. Instead, the North blockaded the Texas coast, leading to nearly three dozen Confederate blockade runners running aground or sinking off the coast.

Hurricanes cause shipwrecks as well. Some of Texas's best known maritime figures, including pirates Luis Aury and Jean Lafitte, ran afoul of hurricanes. Plus, hurricanes generate dramatic photographs of ships stranded, sometimes miles inland. Yet Texas's most dramatic shipwrecks were not caused by wind, water, or warfare. The Texas City Disaster, which sank three big freighters and a number of barges, was an industrial accident, an explosion caused by a fire aboard a freighter.

Yet most Texas shipwrecks occur without the glare of publicity or fame. A ship trying to negotiate a tricky channel runs aground. A river steamboat hits a snag, ripping its bottom open. Storm waves overwhelm a ship at sea, sending it anonymously to the bottom.

One of the most common reasons for a ship to sink is the most prosaic: neglect. When a ship is no longer economical, some owners tie it up, strip it of anything valuable, and leave. They may formally abandon it or just leave it tied up. Then, water slowly leaks in until one day it suffers a catastrophic loss of buoyancy and sinks.

All shipwrecks, from the most dramatic to the most humdrum, hold a story. Often that story is more valuable than a cargo of pirate gold. The information within a historic shipwreck is like a time machine, carrying us to past years. *La Belle*, when discovered, told us about how people lived in the 17th century. So do the anonymous ships lost over the years. They tell us about technology, society, history, and commerce.

A historic shipwreck is any ship sunk for more than 50 years. If it has been on the bottom less than 50 years, it can be salvaged. What if it is a historic shipwreck? In Texas waters, it is subject to the Texas Antiquities Code, passed in 1969. This puts it under the jurisdiction of the State of Texas. You need a permit to remove objects from a historic shipwreck anywhere in Texas, buried underground, on the bottom of Texas rivers, or sunken in Texas coastal waters. The law is intended to preserve the archaeological value of a shipwreck from those who would loot it for the (usually nonexistent) treasure aboard.

Texas went all the way to the US Supreme Court to protect Texas shipwrecks after a salvage company ripped apart one of the 1554 wrecks, seeking the silver and gold aboard it. Texas has since taken action against those collecting souvenirs from the various Civil War wrecks in Texas waters.

It may seem like a downer not to be able to carry off something from a historic shipwreck for your man cave, but this protection permits proper study of Texas shipwrecks. Archaeologists spend a lot of time examining Texas shipwrecks, preserving them, and restoring the artifacts found aboard them. After study, they are often displayed in museums around the state, where anyone can see them.

Besides, it is not as if new shipwrecks are not happening all the time. In 2014, a sailboat capsized during a sudden squall on Galveston Bay. The family aboard was taken to a local hospital. There they gave false names and disappeared. Later, it turned out they planned to use the sailboat to skip to Central America with loot from a confidence scheme. Instead of making a quiet getaway, their departure created an attention-getting splash. It sounds like something from the days of Jean Lafitte, but it happened in 2014. It is a shipwreck story as good as any from Texas's past.

One
LET'S TALK SHIPWRECKS
FIVE CENTURIES OF TEXAS WRECKS

Where can shipwrecks be found around Texas, and where do they come from? People do not set out to wreck ships, except in action novels or during wars, or do they?

Before starting out to look at Texas shipwrecks, it is worth understanding where shipwrecks can be found, why ships end up becoming wrecked, and why shipwrecks are important. The following is a short visual journey exploring the distribution of shipwrecks and the causes of shipwrecks.

This chapter also explores why shipwrecks so fascinate people, and what can be learned from them. Additionally, it is worth learning about what to do if one does run across a Texas shipwreck, especially a historic shipwreck. Shipwrecks are a visual depiction of Texas history, and their study allows everyone to learn more about it. But shipwrecks are also interesting because each has its own story.

Sometimes, as in the case of the 1554 wrecks, the story reads like an adventure novel. Sometimes, as in the case of *Lake Austin*, a scow schooner that missed stays (failed to tack) while coming about in a tricky channel and ran aground, the story sounds like a traffic accident. (In a sense, it was.) Sometimes, as with the *A.S. Ruthven*, tied up at dock and abandoned, it sounds almost like a ghost story. But each story is unique. An old waterlogged wooden plank or a corrosion-encrusted bit of metal may not seem to have much to say, but for those who know how to listen, they tell a lot.

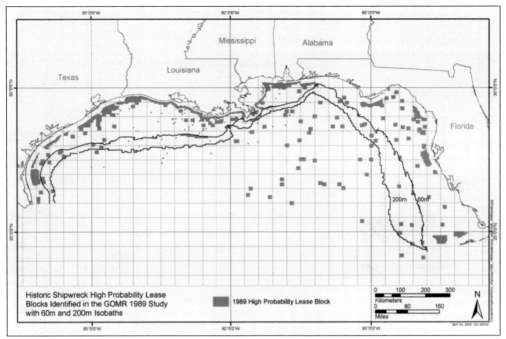

Where are historic Texas shipwrecks most likely to be found? As this map from a Bureau of Energy Management report shows, the best bet is on the coastal shelf of the Gulf of Mexico just off the Texas shore. (BOEM.)

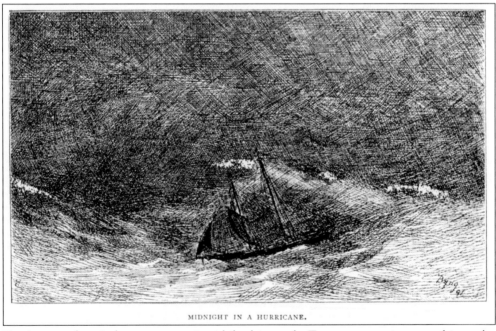

Hurricanes and tropical storms are a major risk for ships on the Texas coast, causing many shipwrecks. They offer two dangers. Storms can swamp a ship at sea or drive them ashore, destroying them through grounding. (AC.)

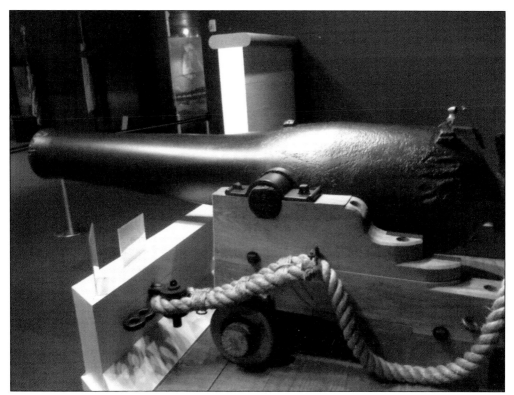

Warfare is another source of shipwrecks. The Mexican and Texas Wars of Independence, the American Civil War, and World War II left traces on the Texas sea bottom. This cannon came from the USS *Westfield*, sunk off Galveston during the Civil War. It sat on the bottom of Galveston Bay for 149 years. It is in the Texas City Museum today. (AC.)

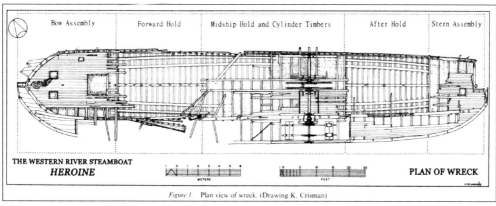

Texas rivers are another source of shipwrecks. For nearly 80 years, from the 1830s through the 1890s, they served as highways for commerce. But Texas's narrow, shallow, snag-filled rivers frequently sank the riverboats steaming on them. *Heroine* was carrying supplies on the Red River when its bottom was ripped out by a sunken log. This plan shows what was left when the steamboat was excavated in the 21st century. (Keven Crisman.)

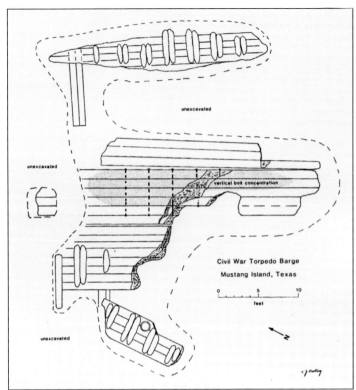

Not all Texas shipwrecks are ships. This odd collection of timber was a raft intended to help clear torpedoes (mines today) from the approaches to Charleston harbor during the Civil War. It broke its tow off Cape Hatteras and drifted down the Atlantic coast, across the Caribbean, and through the Yucatán Channel into the Gulf of Mexico before washing ashore on Texas's Mustang Island. Stranger still? The raft, two layers of 14-inch timbers, was upside down. (Tom Oerling.)

Some of the shipwrecks are unconventional in other ways. SS *Selma* was built during World War I with a concrete hull, because steel was in short supply. A tanker, it sank in Galveston Bay in shallow water near Pelican Island in 1922. Nearly 100 years later, it is still there. (WL.)

Whether a ship sinks or runs aground, time and tide work a similar pattern on the wreck, as is shown in this drawing. The upper works of the ship, especially if it is made of wood, disintegrate, leaving the hull and its contents for the marine archeologists to find. (BOEM.)

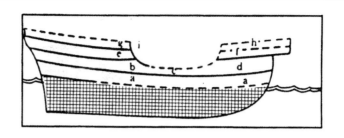

- (a) The overlop, or nether overlop, or upper lop.
- (b) The somercastle, or nether deck, or barbican.
- (c) The waist.
- (d) The nether deck in the forecastle.
- (b) (c) and (d) together are occasionally called the upper overlop.
- (b) and (c) together are frequently called the nether deck.
- (i) The breast of the ship.
- second deck.
- (f) The middle deck in the forecastle, or the upper forecastle.
- (g) The highmost or highest deck, or the upper deck, or the deck; or (probably when shortened to a poop) the small deck.
- (h) The upper deck in the forecastle (not in small ships).

FIGURE II-22. Structural preservation, 16-18th century vessel.

Considering taking a souvenir from a historic Texas shipwreck? Think again. Reason number one: all historic wrecks in Texas waters belong to the State of Texas. Texas went all the way to the Supreme Court to establish that before the 1554 wrecks were discovered. (LOC.)

13

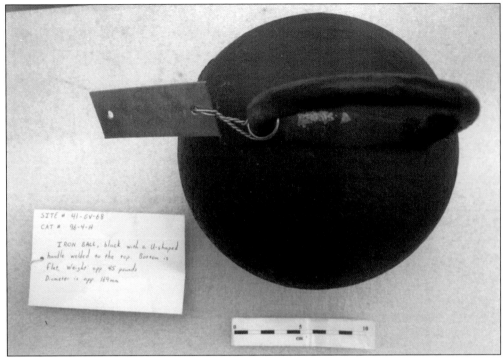

What about naval wrecks? Reason number two for leaving Texas shipwrecks alone: naval wrecks are still federal property. When a salvage company removed this cannonball from the wreck of USS *Hatteras* 20 miles southeast of Galveston, the US Navy sued and got it back. (USNH&HC.)

Reason number three to not take anything from historic Texas shipwrecks: it is so hard to see, it can be dangerous. Texas waters are muddy and turbid. This diver was on-site at the Denbigh project, an archeological examination of a Civil War blockade runner. He is two feet from the cameraman. (Denbigh Project.)

Reason number four to not take anything from historic Texas shipwrecks: where stuff is and its location in a wreck matters to archeologists. Rooting around in muddy Texas water for something eye-catching—like this pitcher found in the wreck of the *New York*—destroys its historical context, as well as the context of any other objects moved around. (BOEM.)

Does this mean one cannot dive on Texas shipwrecks? Not at all. Just do not take anything from historic wrecks (except fish, in season) and do not disturb them, either. For those into exploring sunken ships, Texas Parks and Wildlife provides wrecks—like this one—through its Ships to Reefs program. (Photograph by Paul Hammerschmidt, TPWD.)

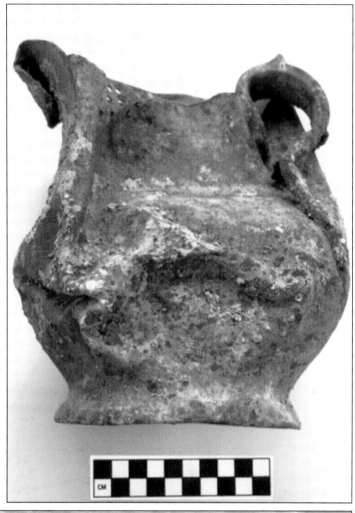

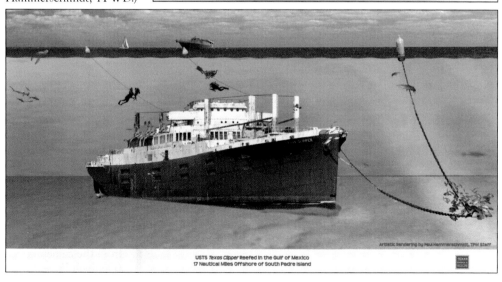

USTS *Texas Clipper* Reefed in the Gulf of Mexico
17 Nautical Miles Offshore of South Padre Island

What is a historic wreck anyway? A historic wreck is defined as anything sunk more than 50 years. This wreck, washed ashore at Galveston by Hurricane Ike in 2009, is just a wreck. While an impressive testimony to the strength of Mother Nature, there is no problem with salvaging it. (NOAA.)

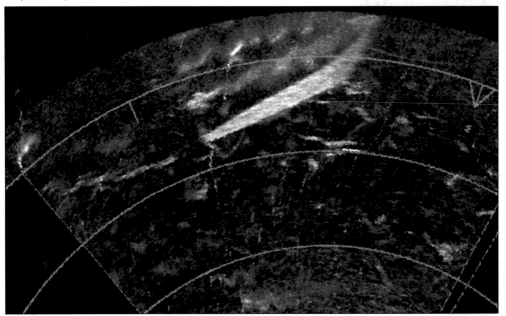

This wreck, shown in a side-scan sonar image, might be historic now because of its age. Located in the Gulf of Mexico south of Texas's Jefferson County, it has not yet been identified. It is believed to be one of five ships that sank between 1909 and 1939. Ordinary commercial ships when they were working, their age has made them interesting to historians. (BOEM.)

Texas has one of the world's finest marine archeology research centers at Texas A&M University in College Station, Texas, in the Institute of Nautical Archeology (INA). When Texas shipwrecks are found, more often than not the artifacts recovered are taken here, to the INA's conservation laboratory. (AC.)

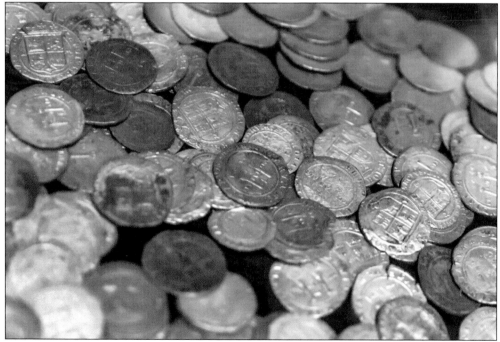

Shipwrecks conjure up images of treasure ships, pirates, and buried treasure. When reading about shipwrecks, the expectation is piles of doubloons and treasure, something out of a 19th-century Howard Pyle story. Sometimes it happens. These silver coins came from one of the 1554 Texas wrecks. (WL, from the Platoro, Keenon, Purvis Collection of the THC and the CCMS&H.)

Shipwrecks do contain treasures, but the real treasures are not typically silver doubloons and gold bars. Rather, it is the ordinary objects, like these, painstakingly removed from a wreck, conserved, and studied. They contain a wealth of information about how ships were built and how people lived during the period the ship was afloat. (WL.)

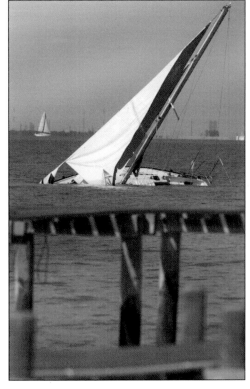

Does romance still exist with modern shipwrecks? Consider this wreck. In November 2014, this sailboat overturned during a squall in Galveston Bay. The owners were apparently attempting to skip the country with stolen money. They were later arrested for fraud. A 21st-century version of Gulf pirates, Jean Lafitte would have approved of everything except the lubberly ship handling. (Photograph by Stuart Villanuevahe, *Galveston County Daily News*.)

Two

EARLY YEARS

1520–1775

For many years after the discovery of the New World, Texas was just a place to sail past. Spanish attention was drawn south to what is now Mexico, lured by the treasures of the Aztec and Mayan empires and the mined gold and silver—especially silver—their new possessions yielded. From their point of view, Texas was a barren wasteland and its coast an inconvenient barrier blocking the way to the Pacific.

Texas entered the world's consciousness after Cabeza da Vaca published an account of his adventures there. Da Vaca, attempting to reach Vera Cruz, Mexico, from Florida by sailing along the Gulf coast in one of four flat-bottomed boats, ended up getting shipwrecked on Galveston Island by a Gulf storm. Da Vaca was a survivor, eventually walking from Galveston Island to New Mexico and rescue.

Texas briefly regained Spain's interest in 1554. That year's treasure fleet, sailing from Vera Cruz to Havana, Cuba, was in sight of Cuba when it got caught in a storm. Pushed all the way back to the Texas coast, three of the four ships ran aground on South Padre Island. Spain salvaged perhaps half the lost silver over the next few years, but kept the loss a secret. The wrecks were soon forgotten.

One ship, *Espíritu Santo*, was found in the 1960s by an oil-exploration firm that entered a deal with a salvage company to excavate the wreck. This led to a court fight in which Texas sued to recover ownership of the wreck. The battle ended in the Supreme Court with Texas victorious—owner of all historic wrecks in Texas waters. A second wreck was destroyed when a channel was dredged across it. *San Esteban*, the third, was found after an archeological search and properly recovered.

The first deliberate attempt to land on Texas's coast was a century later, in 1688. The La Salle Expedition tried establishing a colony on Matagorda Bay. La Salle proved inept, losing two of his three ships. The colony was destroyed by hostile Indians and La Salle was killed by his own men.

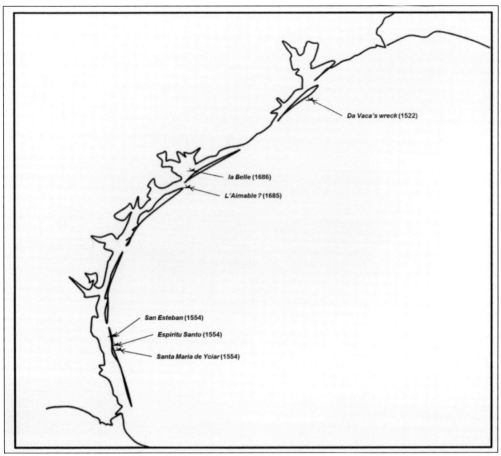

Why so few known wrecks from 1520 through 1750? In large part it is because Texas had not yet become a destination. Except for La Salle's expedition, most shipwrecks along the Texas coast were the result of ships traveling across the Gulf of Mexico getting blown ashore during storms. Even La Salle thought he was at the mouth of the Mississippi River. (AC.)

Cabeza da Vaca did not intend to visit Texas. He was part of a land expedition exploring what is now the southeastern United States. When things went badly, the expedition's survivors built five barge-like boats and attempted to sail them along the Gulf coast to Vera Cruz, Mexico. The boats were separated in a storm. In November 1528, da Vaca's boat and one other washed ashore on Galveston Island. (AC.)

Of the 80 survivors of the shipwreck, 65 died during the winter. Soon only da Vaca and three others were still alive, slaves of the local Indians. The four escaped and walked across Texas, northeast Mexico, and New Mexico before finding other Spaniards and safety. Da Vaca later wrote a book about his travels. (AC.)

The next big Texas shipwreck was in 1554. A four-ship convoy, made up of the *San Andrés*, *San Esteban*, *Espíritu Santo*, and *Santa María de Yciar*, set sail from Vera Cruz with that year's silver. The ships were almost across the Gulf of Mexico when they were caught by a spring gale, which drove them west to the Texas coast. Three of the four ships were driven onto the shoals near South Padre Island. (AC.)

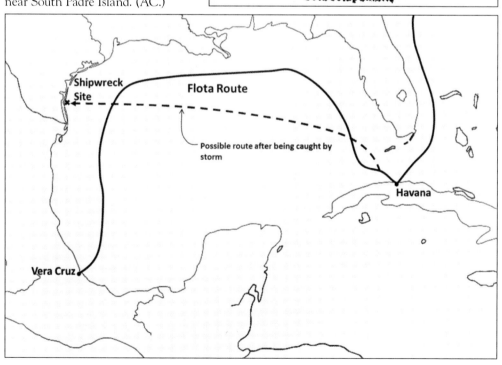

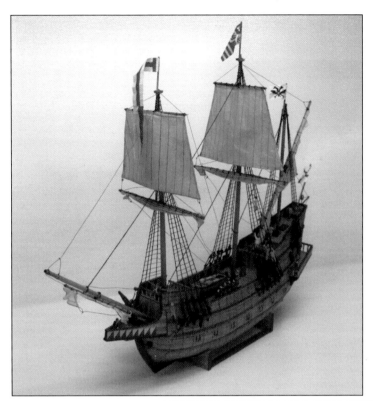

The annual treasure fleets Spain was running between the ports of Vera Cruz, Mexico, and Havana, Cuba, brought the treasure of the New World to Spain. The silver was carried in ships like this model, called *naos*. A nao carried a large cargo, but its high sides and primitive rig meant it could not sail close to the wind and could be blown backward in a strong wind. (AC.)

This model has its own shipwreck history. It was built by William Wardle, who lives on Galveston Island. When Hurricane Ike blew across Galveston in 2009, the model was badly damaged by the storm surge. Wardle rebuilt it, finishing the restoration in 2014. (AC.)

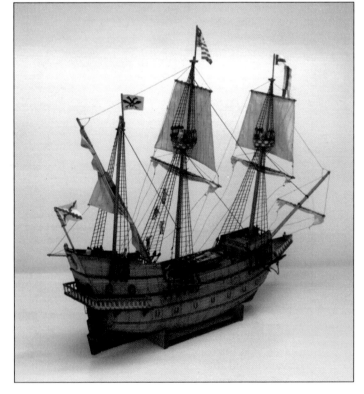

Of those aboard the three wrecked treasure ships, less than half, 150 men, survived to reach shore. They landed on the barren barrier island known today as South Padre Island. With only the clothes they wore and whatever they salvaged from the wrecks, the survivors attempted to walk to Vera Cruz—200 miles away. Only 30 survived. (LOC.)

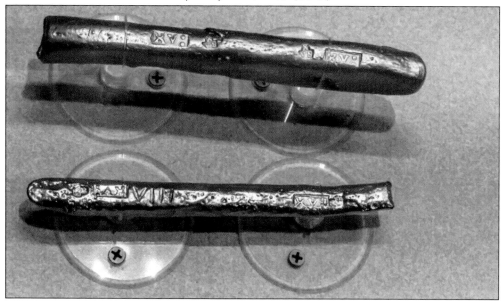

Espíritu Santo was discovered in 1964. In 1967, Platoro Ltd., a private salvage company, began excavating the site in search of treasure aboard. They removed 10 to 15 feet of sand and began recovering silver, gold (such as these gold bars), and other artifacts. The State of Texas sued to stop the excavation, and after a long legal fight, recovered most of the artifacts taken. (WL, from the Platoro, Keenon, Purvis Collection of the THC and the CCMS&H.)

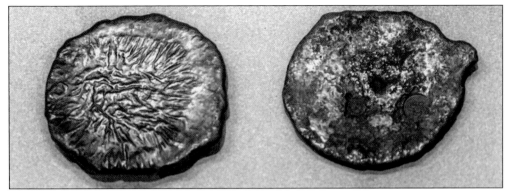

The wrecked ships carried about 87,000 pounds of silver and gold, mostly silver, similar to the silver disks pictured here. The Spanish salvaged the wreck in 1554, recovering 41 percent of the bullion, but over 51,000 pounds of silver were left behind. (WL, from the Platoro, Keenon, Purvis Collection of the THC and the CCMS&H.)

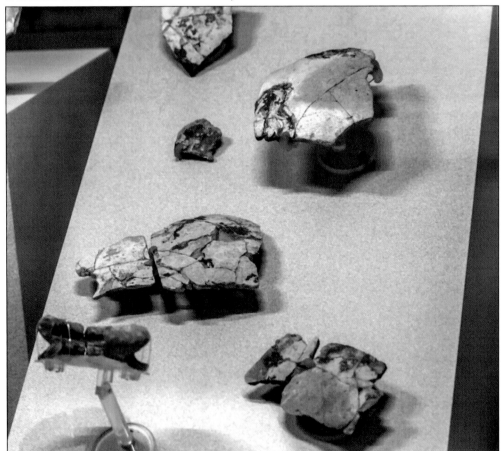

While the sunken treasure evokes fascination, other, humbler artifacts also carry value. These are shards from pots carried aboard *San Esteban*. Analysis showed that the pottery held olive oil for the trip. Learning what was considered important enough to include among the provisions offers insight into life at sea in the 16th century. (WL, from the Platoro, Keenon, Purvis Collection of the THC and the CCMS&H.)

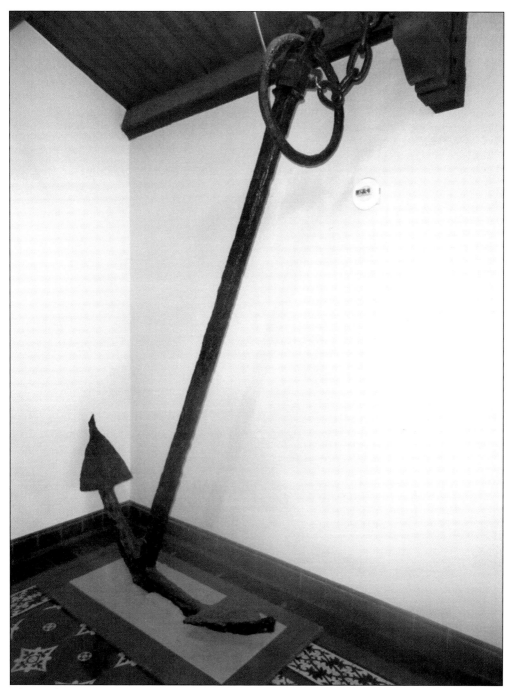

The wreck of *Santa Maria de Yciar* was believed destroyed when the Mansfield Cut was dredged during the 1950s. The wreck's location was then unknown, leading to its inadvertent destruction. Only this anchor, now on display at Texas A&M University at Kingsville, was definitively identified as part of the *Santa Maria de Yciar*. (John E. Conner Museum, Texas A&M University-Kingsville.)

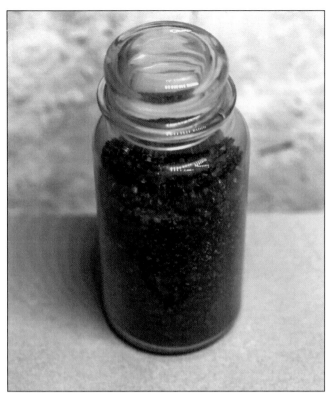

Among the cargo carried by *Santa Maria de Yciar* was over 20,000 pounds of cochineal in 500-pound barrels. Made from insects living in Mexico and South America, it was used to produce carmine, a clothing dye. It took 70,000 insects to fill this jar, which contains one pound of cochineal. (WL, from the Platoro, Keenon, Purvis Collection of the THC and the CCMS&H.)

Only *San Esteban* was properly excavated by marine archeologists. The first step was recording the location of the remains, as shown by a magnetic-resonance plot of the site. The peaks show the highest concentrations of metal, identifying the probable location of cargo, guns, and anchors. (Illustration by J. Barto Arnold, BOEM.)

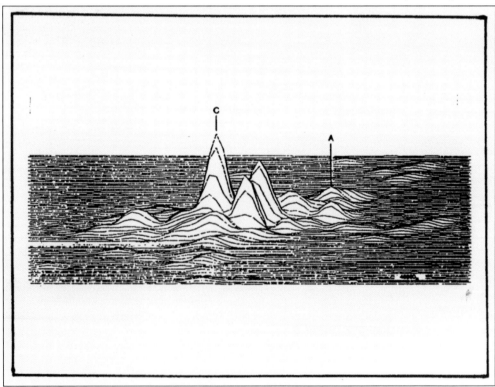

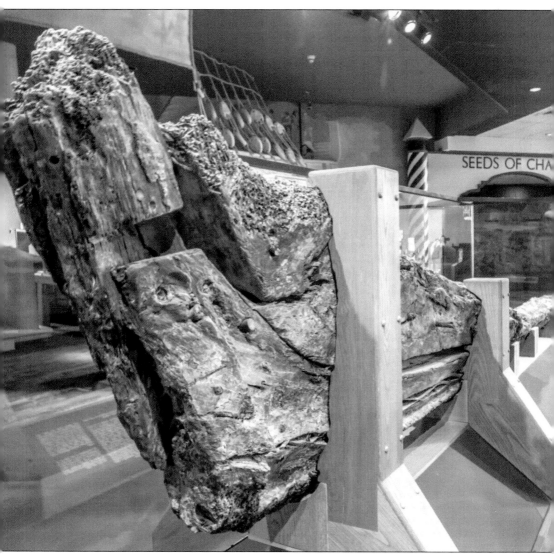

Among the artifacts recovered from *San Esteban* was this timber: the keel, sternpost, stern knee, and several planks. These items are now on display at the Corpus Christi Museum of Science and History. (WL, from the Platoro, Keenon, Purvis Collection of the THC and the CCMS&H.)

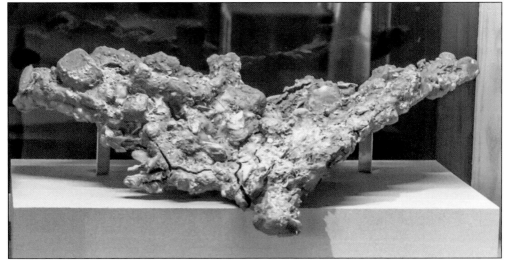

Much of the material recovered came in conglomerates, like the one pictured here. Created by a combination of corrosion, decay, and reaction to the clay in which the wreck rested, conglomerates concealed artifacts as varied as nails, ceramics, or silver, which then had to be extracted and restored. (WL, from the Platoro, Keenon, Purvis Collection of the THC and the CCMS&H.)

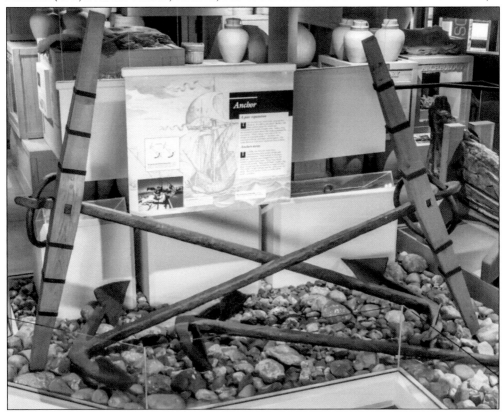

Also on display at Corpus Christi are these anchors from *San Esteban* and *Espíritu Santo*. Ships carried multiple anchors, and Spanish ships generally kept several spares, as theirs tended to break. (WL, from the Platoro, Keenon, Purvis Collection of the THC and the CCMS&H.)

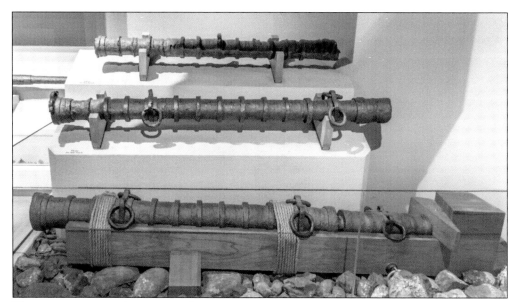

These cannon were also recovered from the wrecks and are now on display. They are bombards, breach-loading cannon used in the 15th and 16th centuries. The bands are iron hoops welded to the barrel to increase strength. (WL, from the Platoro, Keenon, Purvis Collection of the THC and the CCMS&H.)

In August 1684, René Robert Cavelier, Sieur de La Salle, sailed from France with an expedition intending to establish a French colony at the mouth of the Mississippi River. La Salle, then 40, had completed a trip down the Mississippi two years earlier. (AC.)

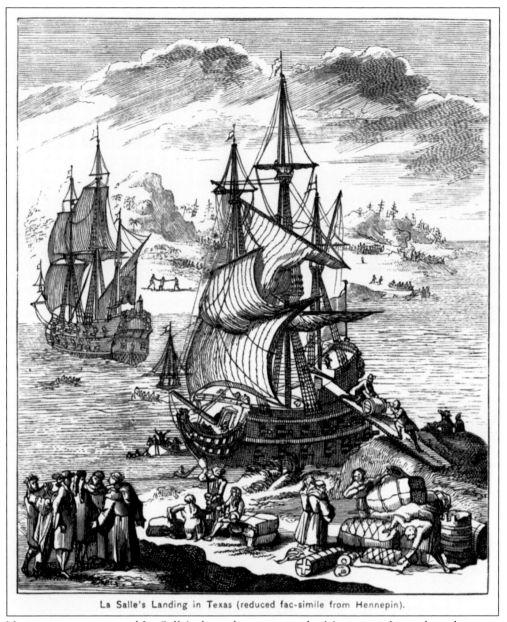

La Salle's Landing in Texas (reduced fac-simile from Hennepin).

Navigation errors caused La Salle's three ships to miss the Mississippi. Instead, as shown in this illustration, La Salle and his colonists landed in Matagorda Bay, deciding it had to be the Mississippi. Things quickly got worse for the ill-starred expedition when its store ship, *Aimable*, sank in Pass Cavallo and the naval warship *Joly* left. Only *la Belle* remained. (AC.)

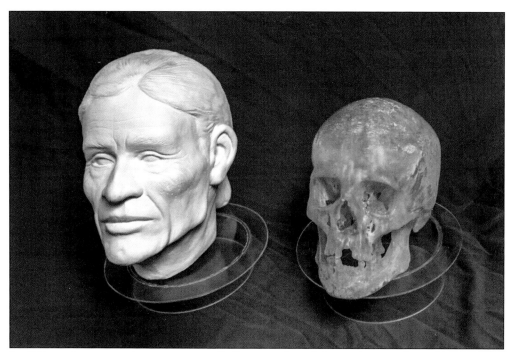

La Belle sank at its anchorage in a squall. One member of the anchor watch tumbled into the hold, killed by the fall. His body was found in the wreck when it was excavated. The resin cast of the skull (right) was used to create a facial reconstruction of the sailor's appearance. (WL.)

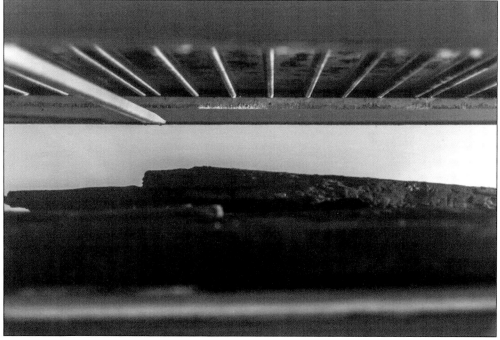

The artifacts and timbers were conserved and restored at the Institute for Nautical Archeology's ship conservation research laboratory. This photograph shows some of timbers of *la Belle* in the facility's freeze-dry chamber, the final step in the conservation process. (WL.)

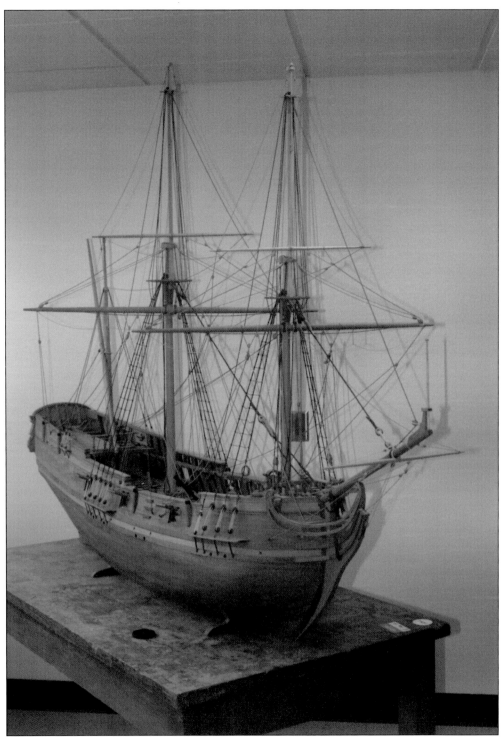

La Belle yielded a vast amount of information about 17th-century shipbuilding. Glenn Grieco of the Ship Model Laboratory at Texas A&M built this model for display at the Bullock Texas State History Museum. (Glenn Grieco.)

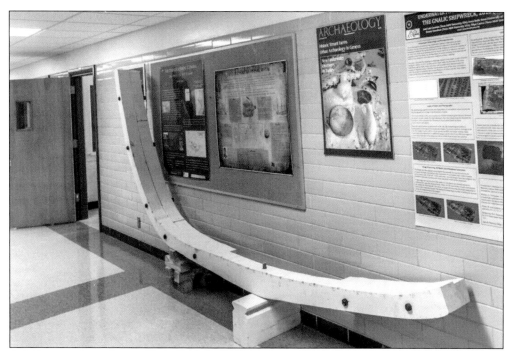

A full-size replica of one of *la Belle*'s frames was also built at the Ship Model Laboratory to help better understand its construction. It is on display at the Texas A&M Center for Maritime Archaeology. (WL.)

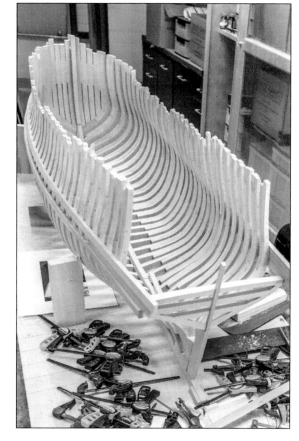

Feeling he can do an even better recreation of *la Belle*, Grieco is building a third large-scale model of the ship. This is a miniature recreation of the actual ship, using materials similar to what was used and duplicating period construction. (WL.)

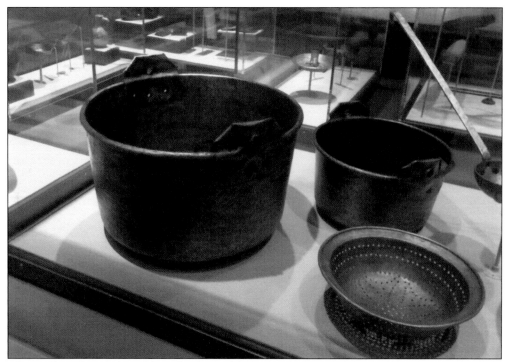

The artifacts found aboard *la Belle* also yielded a vast amount of information about life in the 17th century and in a French warship and colony. These cooking utensils were used aboard the ship to prepare food for the ship's officers and gentlemen adventurers. (AC.)

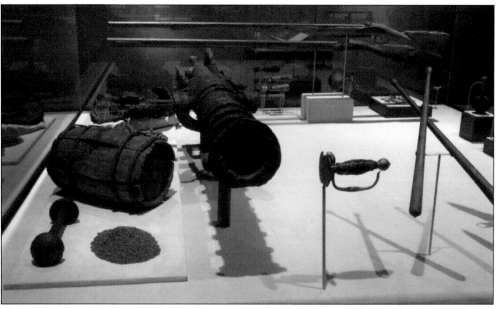

The wreck also yielded an abundance of weapons, such as these now on display. Among the objects are a bar shot, a powder barrel, a bombard, several muskets, and a sword hilt. (AC.)

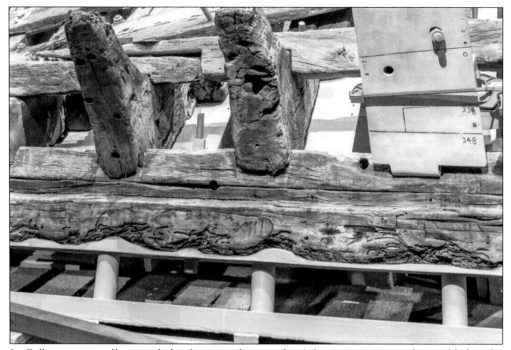

La Belle was originally intended to be carried across the Atlantic in pieces and assembled in the New World. The ship had markings on the keels and frames to aid assembly, like a full-scale model ship. Instead, due to a lack of cargo space, it was assembled in France, both to free up space aboard the ship intended to carry it and provide extra cargo capacity. (WL.)

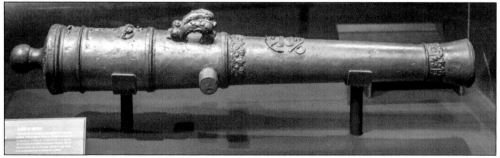

Four brass cannon were stored in the hold of *la Belle* when it sank. These were probably intended to be used to defend the settlement, but were never unloaded. Three were found, including this one, and restored for exhibit. (WL.)

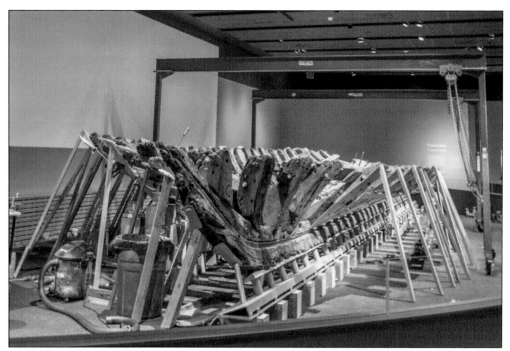

Once the remains were conserved, the timbers were taken to Austin and reassembled. *La Belle* is now on permanent display at Bullock Texas State History Museum. (WL.)

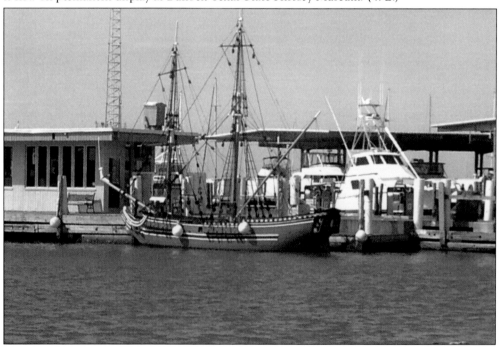

Today, *la Belle* has been adopted by Texas and its citizens as a symbol of the state's maritime heritage. Enthusiasm for the ship led to the construction of *la Petite Belle*, a half-scale replica of La Salle's ship. The replica cruises the Texas coast, raising awareness of Texas maritime history. (Hal DeVaney.)

Three
NEW NATIONS
1776–1845

Texas pretty much remained a pass-by coast for another century after La Salle's colony collapsed. Spain established some missions, but those were mostly inland. Texas remained a backwater even after the American Revolution started, an event marking the beginning of an age of revolution lasting nearly 70 years. Once the Napoleonic Wars started in 1803, and especially after 1808 when France occupied Spain, attention began turning to Texas. The Gulf of Mexico and Caribbean seethed with insurrection as Spanish colonies began striving for independence.

At first, Texas only drew pirates like Luis Aury and Jean Laffite. (Both lost ships to hurricanes while here.) Pirates drew the US Navy and Royal Navy to chase them out. Privateers chartered by new nations like Cartagena, Costa Firme, and Caracas appeared, followed by national warships of those nations. They crisscrossed the Gulf of Mexico, sometimes sinking in battles or storms.

In the 1820s, Mexico declared independence, scooping Texas away from Spain. Soon after, Mexico began colonizing Texas, drawing people from the United States to fill the empty Texas prairies when too few Mexicans showed an interest in moving north.

Yet all was not well in Mexico. Several Mexican states, including Texas, declared independence between 1834 and 1845. This led to a series of wars, as Mexico attempted to force the rebelling provinces back into union. Only Texas made independence stick, in large part due to the efforts of the Texas navy.

The constant naval warfare in the Gulf over a 30-year period created a bumper crop of historic Texas shipwrecks. These include warships on the various sides of the conflict and also ships sunk by blockading forces—sometimes Spanish, sometimes Texan, but usually Mexican—as each side strove to prevent resupply by sea.

The Republic of Texas remained independent for less than a decade, however. It voluntarily merged with the United States on December 29, 1845. Texas annexation brought a close to the age of revolution. Warfare on the Gulf ended, interrupted only briefly during the Civil War.

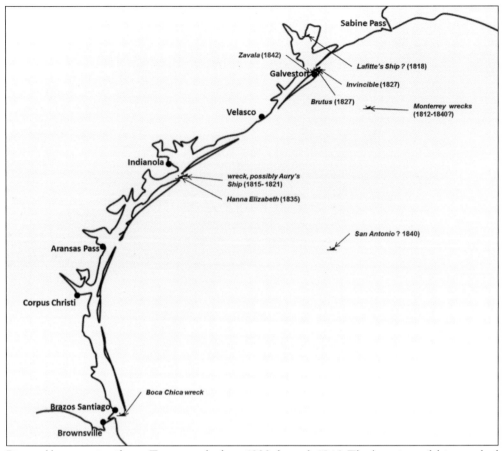

Pictured here are significant Texas wrecks from 1800 through 1846. The locations of ships marked with a question mark are conjectural. A known wreck that has not been positively identified is labeled "possibly," with a guess as to what it is. (AC.)

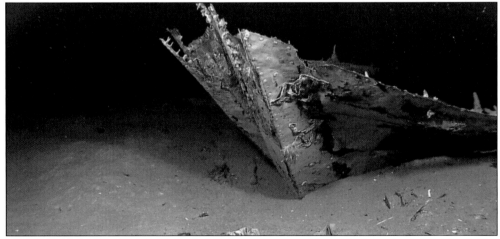

In 2011, three shipwrecks were discovered in the Monterrey oil lease block south of High Island. The wrecks, 170 miles from the coast and 4,300 feet below the Gulf's surface, date to the early 1800s. One ship, the stern of which is shown here, was explored in 2012. (NOAA, Okeanos Explorer.)

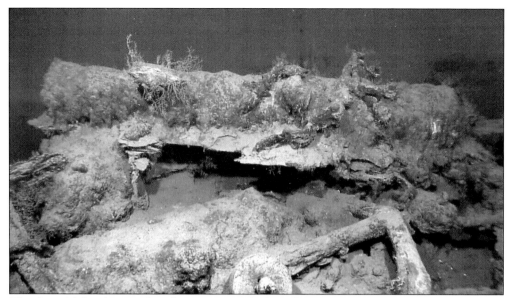

The ship, 86 feet long and 26 feet across, might have been a privateer. It was carrying several cannon, including this long smoothbore found near the ship's bow. (Note the anchor next to the cannon.) The other two wrecks, found south of this one, had no artillery. They may have been escorted by the first vessel or captured by it. (NOAA, Okeanos Explorer.)

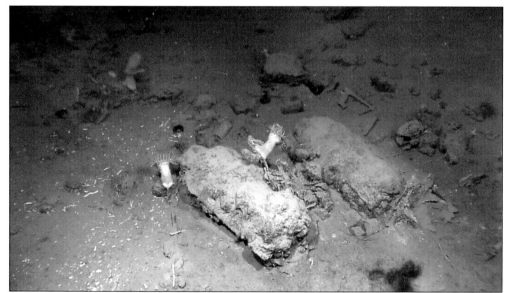

Alternatively, all three ships might have been a convoy of merchant vessels carrying military supplies to one of the various revolutionary nations active in the Gulf of Mexico during the period. These two cannon, either mortars or carronades, were found amidships, apparently unmounted. Perhaps all the artillery was just cargo. (NOAA, Okeanos Explorer.)

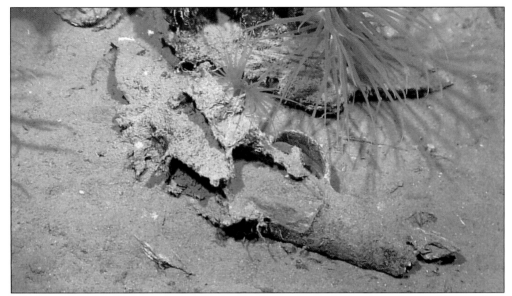

The ship also carried numerous muskets. This is the trigger mechanism of one of the muskets around the wreck. The muskets could have been for the marines carried by a privateer or part of a cache of muskets to be delivered to a revolutionary army. (NOAA, Okeanos Explorer.)

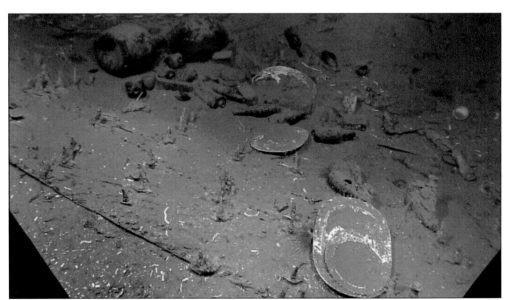

Regardless of whether the ship was a warship or a merchantman, it offers a fascinating window into the construction of vessels in the early 19th century and life aboard them. In the stern of the ship, where the officers lived, china plates and bottles can be seen, along with the copper nails that held the hull together before the wood was ravaged by time. (NOAA, Okeanos Explorer.)

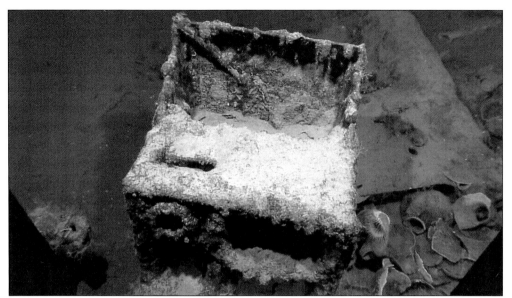

Near the bow, where it was traditionally located, the galley stove can be seen, guarded by sea anemones. The crew's meals would have been cooked here. (NOAA, Okeanos Explorer.)

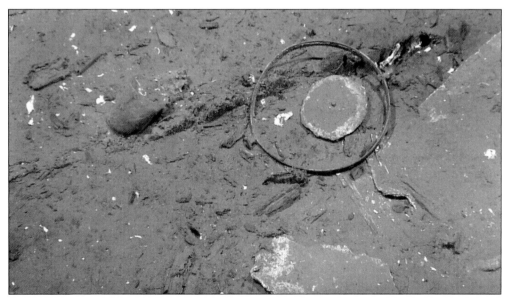

On the quarterdeck, the compass and the ring holding the vanished compass card can be seen. Metal, especially brass, resists the destructive effects of seawater better than wood or paper. (NOAA, Okeanos Explorer)

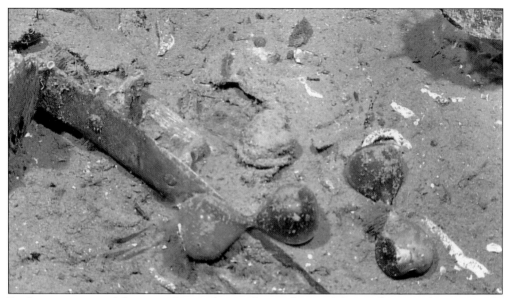

By the compass, sandglasses used to track time during the watch lie on the ocean bottom. Made of glass, they are impervious to wear. A further expedition in 2013 explored the other two ships. (NOAA, Okeanos Explorer.)

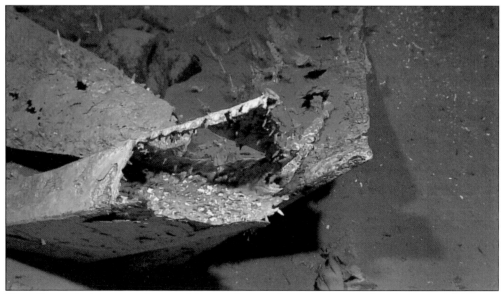

The effects of saltwater and ocean life on a shipwreck can be seen in this close-up of the stern. Much of the wood is gone, eaten or rotted away, leaving only the illusion of sturdiness created by thin copper plating that once sheathed the lower hull. Even that has been eaten by corrosion. (NOAA, Okeanos Explorer.)

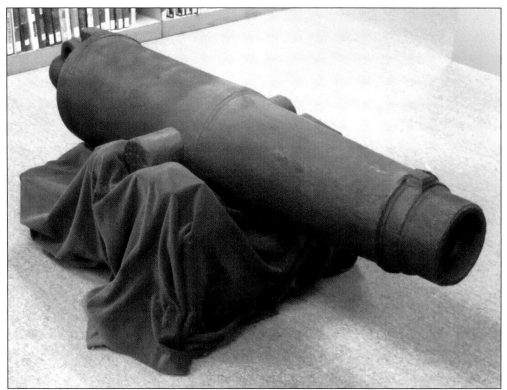

This gunnade, cast in England between 1805 and 1825, was found aboard a wreck off Pass Cavallo. The identity of the ship is uncertain. It might have belonged to Luis Aury, a successful Gulf pirate between 1815 and 1821, who lost a ship in a hurricane near Pass Cavallo in the early 1820s. Equally, it could be off a ship that sank during the Mexican or Texas Revolutions. (AC.)

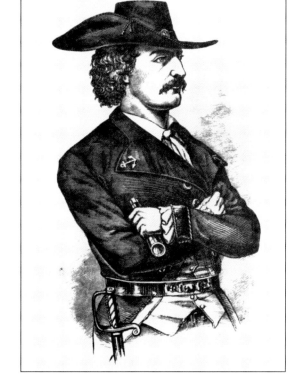

Aury was not the only Gulf pirate who lost a battle with a hurricane. Jean Lafitte, pictured here in a 19th-century history book, is said to have lost a vessel in Trinity Bay during a hurricane in September 1818. (AC.)

Matagorda Bay, especially the ports at Cavallo Pass, provided access to the central Gulf coast, since Texas was a Mexican colony. When Texas rebelled against Mexico in 1835, Mexico sent warships to blockade the pass. (AC.)

The *Hannah Elizabeth* was a small merchant schooner, similar to the one pictured. Smuggling a cargo of munitions to Texan troops at Goliad, it wrecked at the entrance of Pass Cavallo on November 19, 1835, while trying to evade the Mexican warship *Moctezuma*. The wreck was rediscovered in 1999 and excavated in 2001. (AC.)

To protect Texas from Mexico's navy, the Texas revolutionaries created their own navy. Initially, it had four ships, all schooners. By August 1837, only two remained: *Invincible* and *Brutus*. *Invincible* was trapped outside Galveston when attacked by two Mexican warships. Attempting to reach harbor against contrary winds, it ran aground and was wrecked. (Exxon Corporation.)

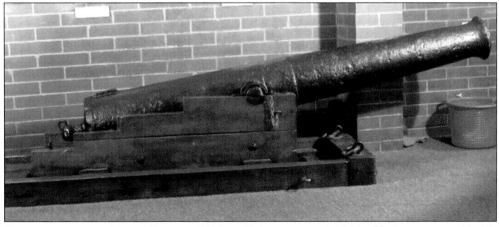

Seeing its partner in distress, *Brutus* sailed from Galveston to assist *Invincible*. It ran aground inside the harbor. A storm destroyed *Brutus* a few days later before it could be refloated. Its 18-pound pivot gun was discovered in 1884 when Galveston Harbor was dredged. It is now on display at the Texas Maritime Museum. (AC.)

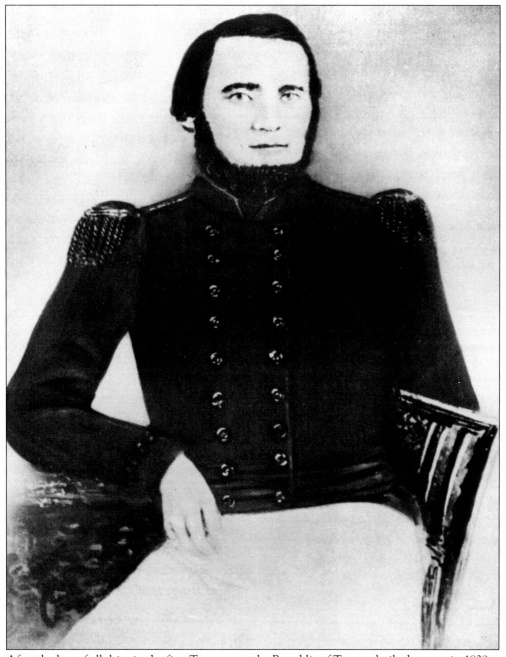

After the loss of all ships in the first Texas navy, the Republic of Texas rebuilt the navy in 1839: a sloop-of-war, two brigs, three schooners, and a steam warship. Command was given to Commodore Edwin Moore, pictured here. (USNH&HC.)

Another Texas navy ship lost in the Gulf of Mexico was *San Antonio*, a schooner built as a warship. In October 1840, *San Antonio* left Galveston for the Yucatan and disappeared. It is believed that it sank in a storm. (AC.)

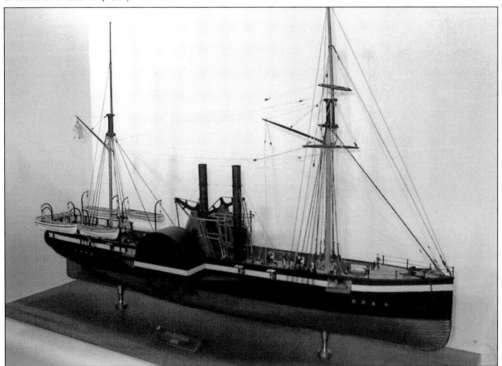

Not all Texas navy warships were lost in battle. *Zavala*, the Texas navy's only steam warship, was laid up in Galveston in 1840 to await repairs and sank at its moorings in 1842. Clive Cussler located what he believed to be *Zavala*'s hull beneath a Galveston parking lot in 1986. He had two models of the ship built. One was donated to the State of Texas. (Clive Cussler.)

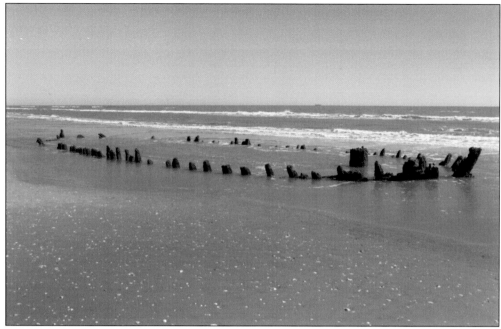

Some Texas navy enthusiasts believe this may be the *Moctezuma*. On April 3, 1836, near the mouth of the Rio Grande, the Texas warship *Invincible* fought a battle with the Mexican warship *Moctezuma*. A fierce exchange of broadsides damaged both ships but left *Moctezuma* sinking. It ran aground near where this wreck was found. (Steve Westmoreland,)

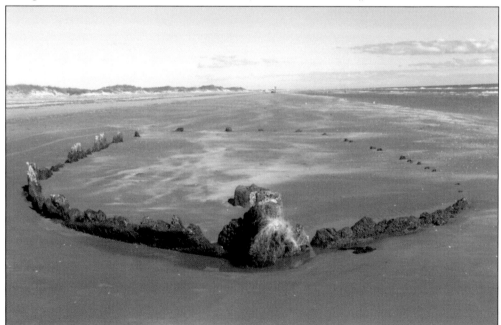

In 1999, Hurricane Bret uncovered the remains of this shipwreck. While it is similar in size to *Moctezuma* and near where the battle was fought, the Texas Historical Commission believes this wreck, which is identified as "Boca Chica 2," is more likely to be the wreck of a commercial brig than a Mexican navy warship. Whatever it is, the wreck is visually impressive. (Steve Westmoreland.)

Four
THE CIVIL WAR
1861–1865

The American Civil War yielded another crop of shipwrecks off the Texas coast and estuaries. There were three main causes of shipwrecks: naval battles, blockade running, and natural hazards.

Three significant naval battles were fought in and around Texas: the Battle of Galveston on January 1, 1863, the battle between the Confederate raider CSS *Alabama* and the Union gunboat USS *Hatteras* on January, 11 1863, and the Battle of Sabine Pass, fought on September 8, 1863. The US Navy, almost universally successful during the Civil War, seemed jinxed once west of the Sabine River in Texas waters. The Union lost all three battles, leaving ships stranded or sunk on all three occasions.

Not everything went the Confederacy's way. The Union Navy destroyed six small Confederate warships off Texas and successfully captured Brazos Santiago and Port Isobel in summer 1864, in a combined Army and Navy expedition. Its occupation cost the Union another half-dozen ships, stranded and wrecked in the shallow waters around Brazos Santiago or sunk in storms carrying supplies there. Blockading ships were also lost through storms or shoals.

Blockade running was another source of shipwrecks during the Civil War. With the Union blockading the Confederate coasts, the only way to get goods into the Confederacy and cotton out was to evade the blockading warships. That meant approaching the Texas coast at night or during fog and bad weather. The fog, rain, and darkness shielding a blockade runner from Union eyes also shielded shoals and increased navigation errors.

Many blockade runners were lost because they ran aground during approach or departure and were subsequently destroyed by the blockaders when daylight came. Others, spotted on the way in, were beached and burned to prevent capture by the Yankees.

Surprisingly, most blockade runners on the Texas coast were sailing vessels—schooners or sloops. Steamers did not use Texas ports until late in the war—1864 and 1865—after most of the other Confederate ports had been captured and only Galveston was left. Just four blockade-running steamers wrecked off Texas. The wrecks of three have been found.

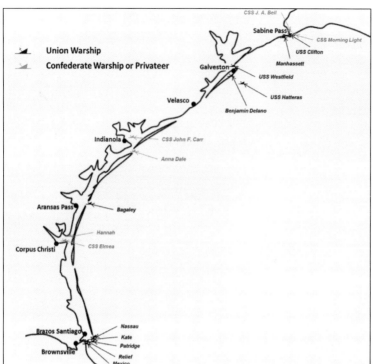

This map features the wrecks of Confederate warships and Union ships off Texas during the Civil War. Three Union warships—*Westfield*, *Hatteras*, and *Clifton*—were sunk during battles; most of the remaining losses were vessels driven ashore during a storm or destroyed after grounding. Generally, this was done to prevent capture by the enemy. (AC.)

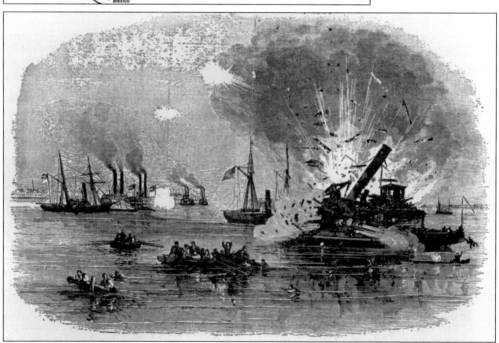

On New Year's Eve 1863, Confederate forces launched a combination land and naval attack to retake Galveston, then occupied by the Union. During the Battle of Galveston, the USS *Harriet Lane* was captured, CSS *Neptune* sank (and was later refloated), and the USS *Westfield* ran aground. To prevent her capture by the Confederates, when the Union Navy withdrew, her captain set explosive charges and blew up the ship. (AC.)

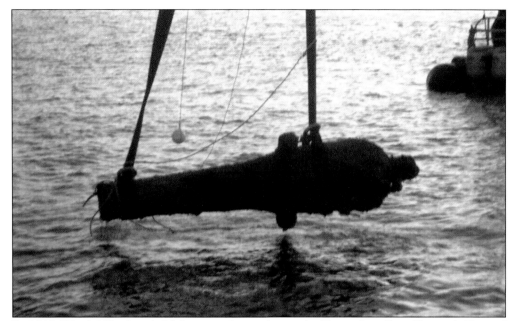

By 2009, *Westfield* had sunk 35 feet into the mud near the Texas City Ship Channel. Planned dredging to deepen and widen the channel would have destroyed what remained, so the US Navy authorized the recovery of historically significant artifacts from the wreck. The recovery began in November 2009. In December, this nine-inch Dahlgren cannon was recovered from Galveston Bay. (Justin Parkoff.)

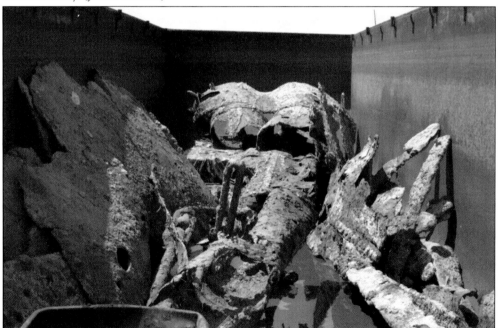

The salvage operation had to be completed in 90 days. Despite the short timeframe, it yielded a multitude of objects, some of which are shown here shortly after being retrieved from the bottom of the bay. All were sent to the Institute of Nautical Archeology conservation laboratory at Texas A&M University for analysis and conservation. (Justin Parkoff.)

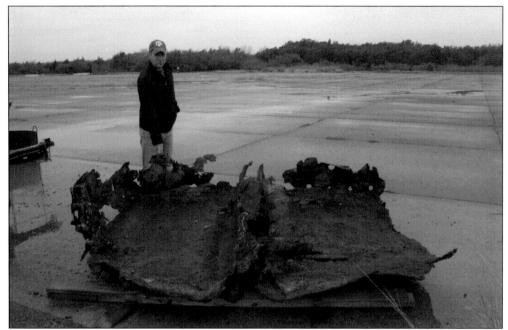

Among other artifacts recovered from the *Westfield* were the remains of the boiler, which is shown here at the INA's conservation laboratory. Plans originally called for it to be displayed at a museum, but the boiler was contaminated with mercury. Instead it will be stored by the INA. (Justin Parkoff.)

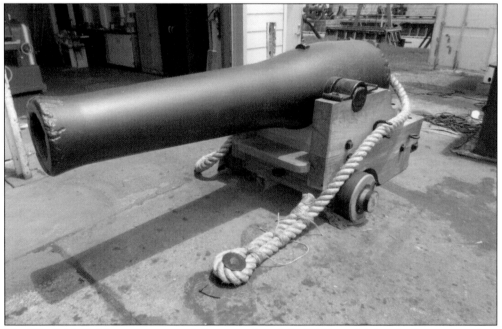

The *Westfield*'s Dahlgren was successfully restored, and the INA's model shop built a new carriage for the cannon. Building the carriage was almost as big an adventure as restoring the cannon. No plans existed, and recreating the type of carriage used by the Navy in the Civil War proved a challenge. (Glenn Grieco, INA.)

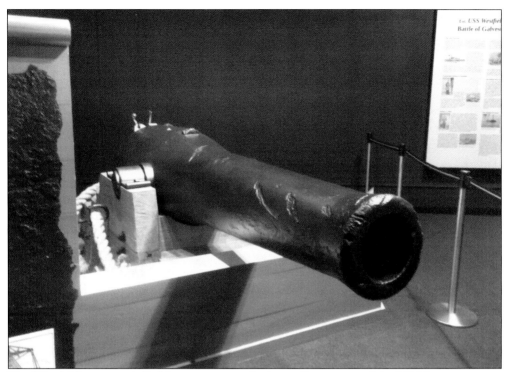

The *Westfield*'s nine-inch Dahlgren cannon, which is still property of the US Navy, is now on display at the Texas City Museum, the centerpiece of its *Westfield* display. (Texas City Museum and USNH&HC.)

After losing Galveston, a Union flotilla was sent to investigate recapturing the port. Also drawn to Galveston was the Confederate raider CSS *Alabama*, lured by reports of a fleet of Union transports. *Alabama* instead discovered a squadron of Union warships when it arrived on January 11, 1863. (AC.)

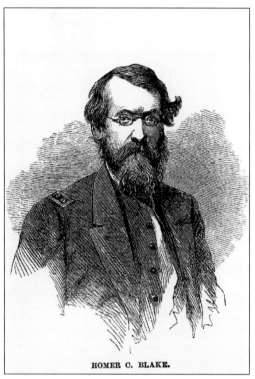

Believing the strange sail sighted to be a blockade-running merchant vessel, the Union commodore dispatched USS *Hatteras*, commanded by Homer C. Blake, to investigate. (AC.)

HOMER C. BLAKE.

While adequate to capture a blockade runner or defeat a Confederate cotton-clad warship, *Hatteras* was completely outclassed by *Alabama*. Lured away and out of sight of its companions, *Hatteras* was sunk after a 20-minute battle. The next day, USS *Brooklyn*, investigating *Hatteras*'s disappearance, spotted its topmasts sticking out of the water. (USNH&HC.)

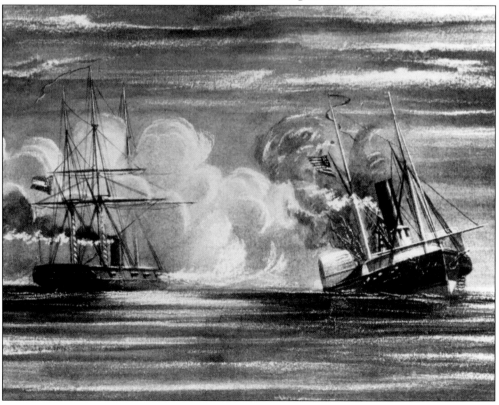

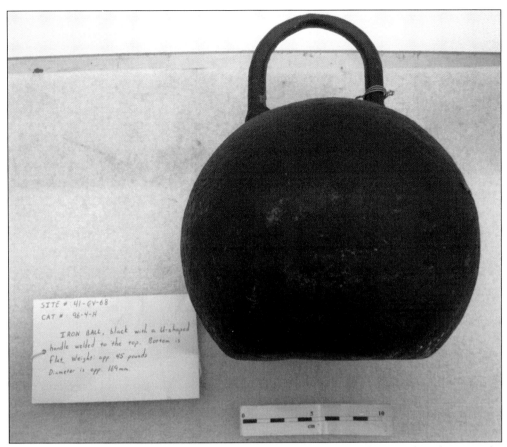

The spot where *Hatteras* sank is only 60 feet deep, accessible to sport divers with scuba gear. The site was known, and in the mid-1970s, an amateur treasure-hunting group attempted to claim *Hatteras*. To bolster their salvage claim, they recovered artifacts from *Hatteras*, including this shell. The US government challenged the claim. *Hatteras* remained federal property and was not subject to salvage. Following victory for the government in a 1981 court decision, the shell and other recovered artifacts were returned to the government. (USNH&HC.)

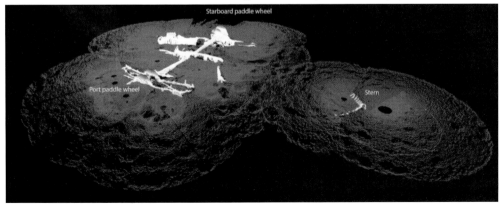

Hatteras has since been preserved as a historical site. Marine archeologists working with the Navy have surveyed *Hatteras* in 1981, 1992–1995, 2006, 2010, and 2012. This three-dimensional sonar map was made during the 2012 survey, showing the appearance of the wreck at that time. (NOAA.)

The shaft and starboard paddlewheel of *Hatteras* is pictured here in 2010. The scale in the photograph is 10 centimeters, with 2-centimeter markings. (BOEM.)

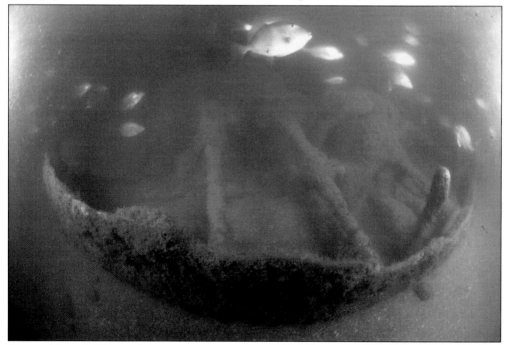

Pictured here is *Hatteras*'s bow as it appeared in 2012. This is possibly the mounting for the forward pivot gun, a 20-pound Parrott. Marine plants grow on the metal as fish swim by. (©Jesse Cancelmo.)

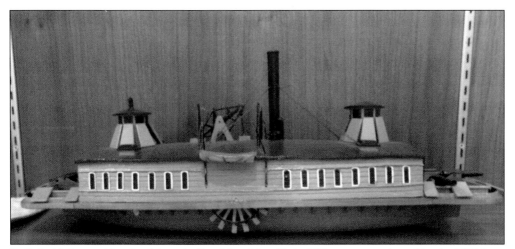

Built in 1861 as a side-wheel ferry in Brooklyn, New York, Clifton was purchased by the US Navy, armed, and converted into a gunboat with light armor protection. This model shows Clifton as it appeared while a US Navy warship. (SHRL&RC.)

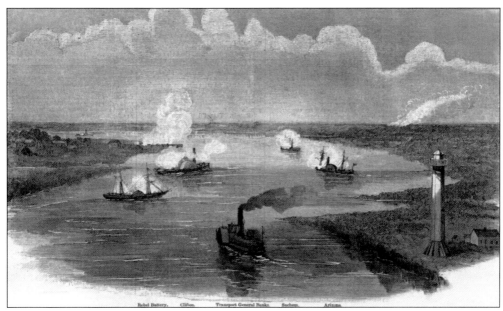

On September 8, 1863, Union forces sailed into Sabine Pass, intent on launching an invasion of Texas. The Union attackers included four armored gunboats and 54 transports, with over 5,000 men aboard. (AC.)

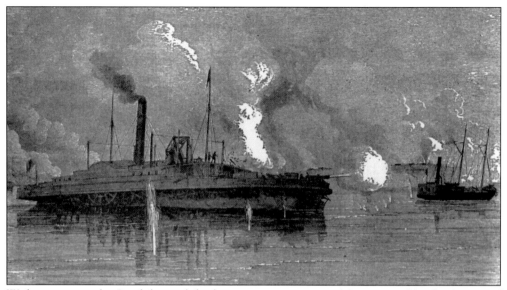

Within minutes, the Confederate defenders, six cannon in a mud fort manned by the 54 men of the Davis Guard, immobilized the Union gunboats. USS *Clifton* was sunk, and the USS *Sachem* had run aground. Both ships were refloated and used in Confederate service. (AC.)

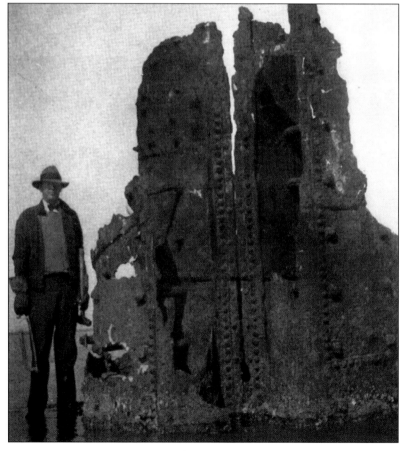

Clifton was burned in 1864 to prevent its recapture by the North. In the early 1930s, its boiler was salvaged and examined as part of a study on Civil War–era metallurgy. As can be inferred from the tools the man holds, destructive testing followed. (Justin Parkoff.)

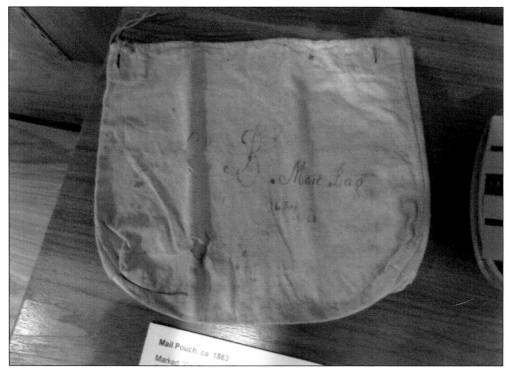

This mail sack, now on display at the Sam Houston Regional Library and Research Center in Liberty, Texas, was taken from *Clifton* after it sank. (SHRL&RC.)

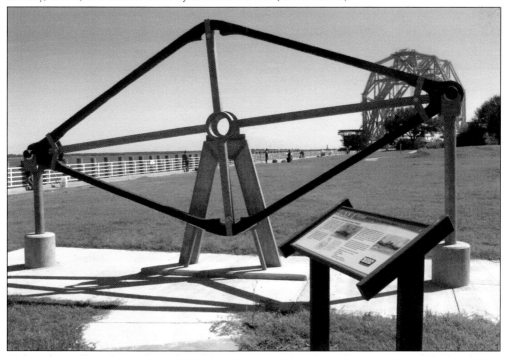

Today, the walking beam from the *Clifton* is preserved at the Sabine Pass Battlefield Park as a memorial. (Civil-War-Journeys.org.)

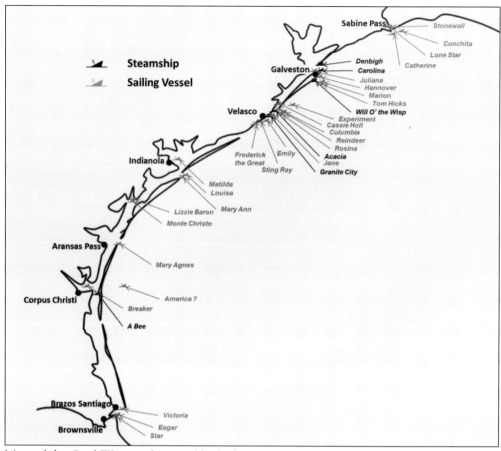

Most of the Civil War wrecks were blockade runners. Some were steamships, but many were sailing vessels. Cotton was the chief cargo smuggled out of Texas. Weapons and luxury goods were brought in. (AC.)

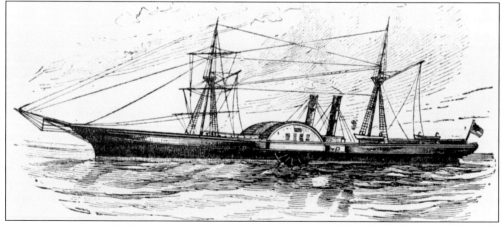

Steamships used as blockade runners usually were custom-built for that function. These ships were similar to the one pictured: long, lean, and light-draft sidewheel steamships designed for speed. Because they were designed for a short lifespan, the wrecks on the Texas coast disintegrated quickly. (AC.)

While many assume steamships made up most of the blockade runners, on the Texas coast at least, most were schooners, such as this one pictured carrying cotton. The fore-and-aft rig allowed schooners to sail close to the wind, and most coastal schooners were light-draft vessels. (AC.)

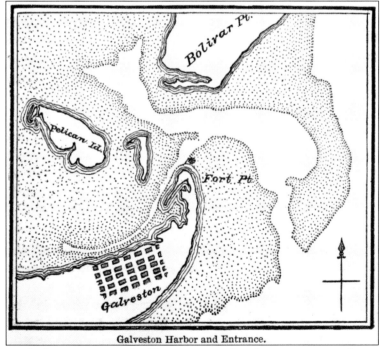

Galveston was the biggest port on the Texas coast, with rail connections to the interior. Once recaptured by the Confederacy, shore batteries protected the harbor from the Union Navy. Its disadvantage for blockade runners, as shown in this Civil War–era map, was the port's shallow approaches and tricky channel. Many blockade runners were wrecked running aground after being fired on by blockading Yankees. (AC.)

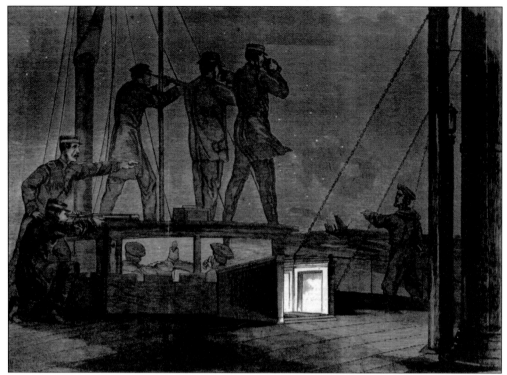

Four steamships ended up wrecked on the Texas coast attempting to run the blockade. By late 1864, when Galveston became the Confederacy's most important port, blockade runners had to run a gauntlet of blockading Union warships. Maximizing chances for success meant blockade runners approached at night, using the cover of darkness and mist. (AC.)

Darkness and mist cut both ways, though. It was easy to miss the channel in the treacherous Texas coastal waters. This sunny beach scene shows where *Acadia*, built in Canada, ran aground on a sandbar off Surfside, Texas, on a dark night in February 1865 and sank while being pursued by a Union warship. (AC.)

A second steamboat blockade runner was found by a magnetometer survey conducted off Galveston Island in 1983. The iron-hulled vessel was identified as *Will-o-the-Wisp*. It also stranded attempting to reach Galveston in February 1865. The results of the survey are shown in this illustration. The peaks represent the greatest concentration of metal, probably the engines. There has been debate recently as to whether this wreck is *Will-o-the-Wisp* or a second steamer, *Carolina*. (BOEM.)

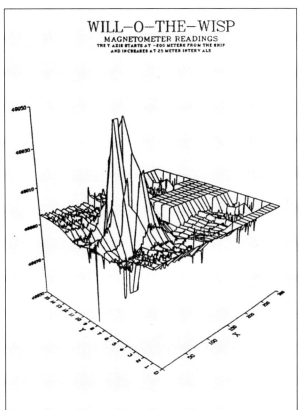

Denbigh, built in Liverpool and used as a fast ferry for two years before becoming a blockade runner, ran aground off Bird Key attempting the run down the Bolivar Peninsula. In 2001, very low tides exposed the wreck. Prof. Tom Oertling took this photograph within walking distance of his Texas A&M Galveston office. (Denbigh Project.)

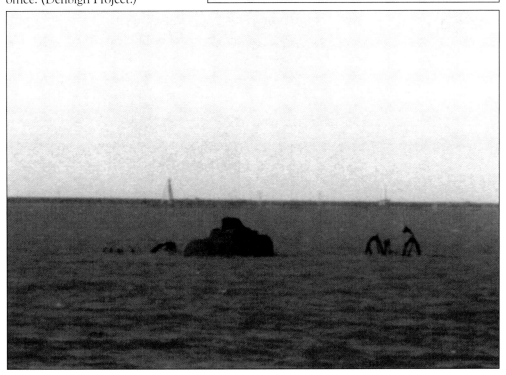

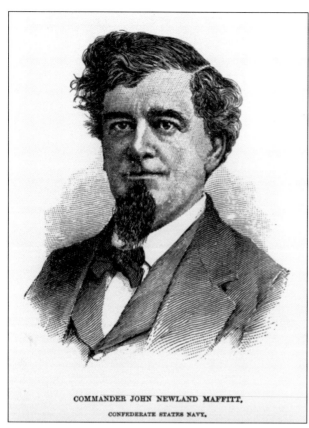

COMMANDER JOHN NEWLAND MAFFITT,
CONFEDERATE STATES NAVY.

Denbigh ran aground on May 25, 1865, after Appomattox, but before Texas surrendered in June 1865. Its final captain was John Maffett, a Confederate naval officer who served as captain of the Confederate raider *Florida* earlier in the Civil War. (AC.)

Pictured here is a firebrick used in *Denbigh's* boiler. When the archeological exploration of *Denbigh* started in 2002, it initially was intended as a commercial study of *Denbigh's* cargo. Once it was discovered the ship's holds were empty, apparently salvaged after the war, it became an engineering study. Much was learned about 1860s propulsion systems. (Denbigh Project.)

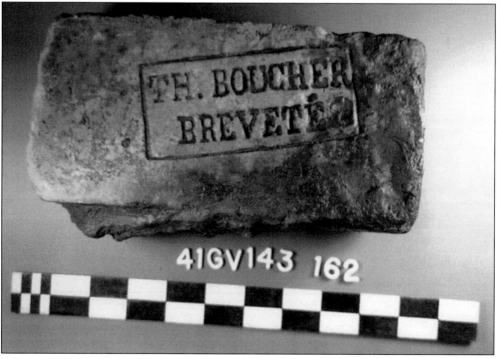

Four

GALVESTON'S GOLDEN AGE
1847–1900

While wars attract popular attention, commerce creates wealth. After Texas joined the Union, commerce along the coast grew explosively, especially following the Civil War, when railroads hit Texas in a big way. Hides, tallow, East Texas timber, and cotton from the interior could easily reach the Texas coast. Refrigeration made frozen Texas beef a new export. The 1890s added oil to the mix. And lots of people wanted to come to Texas.

Over 40 steamship companies served the Texas coast. Two were giants. The Morgan Line was the biggest shipping company serving coastwise trade along the Gulf of Mexico. The Mallory Line was the major carrier from New York and the Atlantic coast to Texas.

Fire and weather posed the greatest threat to the flood of ships sailing Texas waters. Primitive steam engines, wooden ship structures, and often volatile cargos created a dangerous mix. Sometimes, as in the sinking of Mallory Line's *City of Waco*, fire and weather would combine. *City of Waco* could not enter Galveston due to stormy weather when it caught fire and sank. Gale-force winds prevented rescue of the passengers, and 56 aboard died. Sometimes Texas's treacherous shoals contributed, as when the Morgan Line steamship *Mary* struck a buoy in Aransas Pass's narrow channel, took water, and sank.

While ports like Brownsville, Corpus Christi, and Beaumont grew during these decades, the big winner was Galveston. Texas's biggest port and best harbor before the Civil War, it captured much of the new Texas-bound traffic. Its growth was aided by harbor improvements and chance. It deepened its port several times between 1870 and 1900. It was also the only deepwater port really sheltered behind the coastal barrier islands. Rival Texas ports, including Indianola and Aurora (at the mouth of the Sabine River), were destroyed by hurricanes in the 1880s, while Galveston was spared.

Galveston became Texas's queen city due to the ships arriving and the commerce they brought. There was apparently no limit to Galveston's growth, until another visitor arrived in September 1900, bringing with it 5,000 deaths and numerous shipwrecks. The 1900 hurricane ended Galveston's golden age.

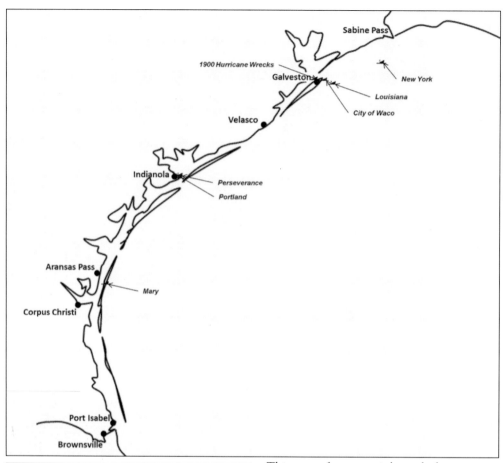

This map of commercial wrecks between 1846 and 1900 shows Galveston's importance to the Texas economy. While some of the ships marked were traveling to other Texas ports, most were headed to or sailing from Galveston. (AC.)

Charles Morgan was a New Yorker, but he owned the largest shipping line in the Gulf of Mexico. Following Texas annexation, Morgan expanded aggressively into Texas ports. The Morgan Line dominated coastal shipping to Galveston, but Morgan's ships sailed into other Texas ports as well. (AC.)

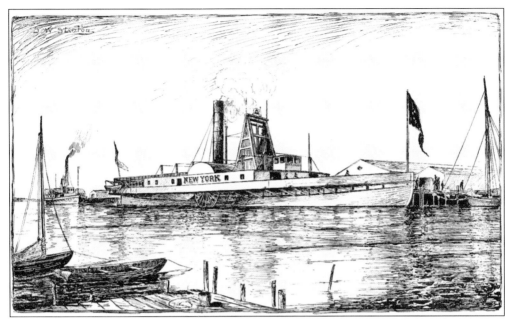

The steamship *New York* was built in New York City and started life on the Atlantic coast. In 1839, it was transferred to the Gulf of Mexico. The wooden-hulled steamer began regular runs between New Orleans and Galveston, one of the first ships on the Gulf run for the Morgan Line. (AC.)

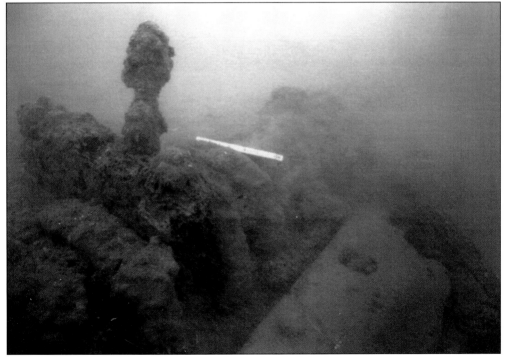

New York left New Orleans for Galveston September 5, 1846. It ran into a hurricane. Heavy seas battered the old vessel. The captain anchored, but the winds soon tore away the smokestack, and the waves sprung the planks. At 4:00 a.m. on September 7, *New York* sank in 10 fathoms of water. This photograph shows the ship's capstan, used to raise and lower the anchor. (BOEM.)

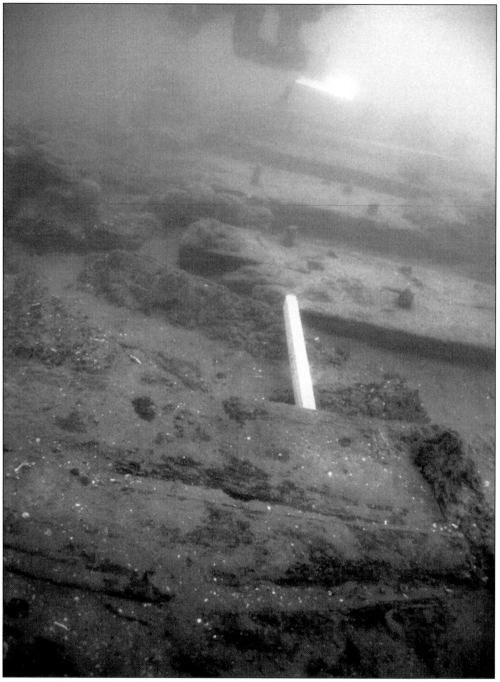

A passing ship rescued 35 of the 54 aboard. *New York* was explored by professional archeologists in 2007. The visit produced spectacular images, including its frames, pictured here. (BOEM.)

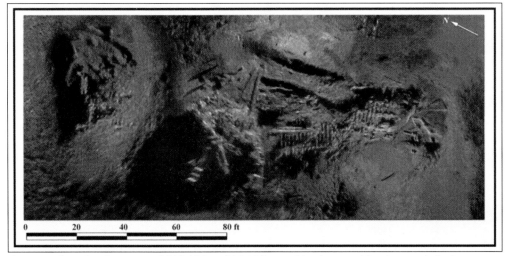

A report that the ship carried $30,000 to $40,000 in gold, silver, and banknotes led a Louisiana oilfield worker to search for it. Later searches used sophisticated tracking methods, such as this sector-scan sonar image of *New York* made during the 2007 survey. The worker found it using reports of snagged shrimp nets. (BOEM.)

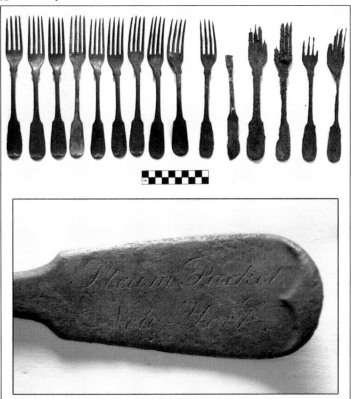

The initial salvage effort was a commercial venture by a company called Gentlemen of Fortune. They only found a handful of the gold and silver reportedly aboard *New York*. Perhaps most of the cash aboard was greenbacks. They did recover many artifacts, such as these silver forks, photographed for the Bureau of Energy Management. (BOEM)

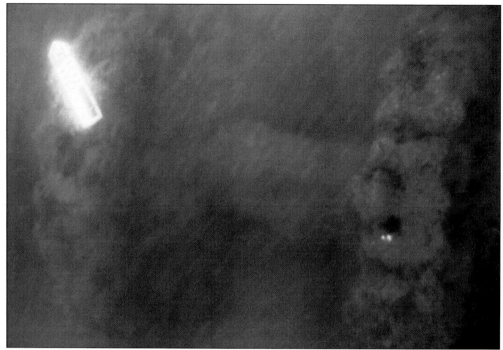

The real treasure of *New York* proved to be not the gold and silver it carried, but the information it revealed. *New York* had a low-pressure crosshead steam engine, one of the earliest types of marine steam engines. The paddlewheel hub, shown here, was driven by the steam engine. (BOEM.)

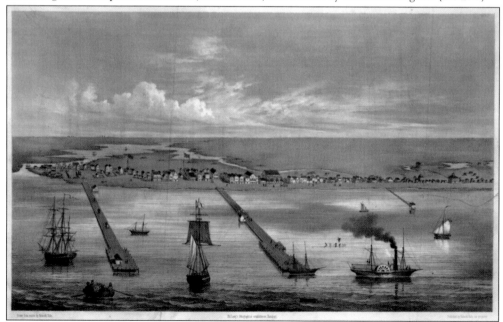

The town of Indianola became a deep-water port in 1848. Its growth was assured when Charles Morgan chose it as the Lavaca Bay terminus for the Morgan Lines in 1849. By 1860, the date of this painting, it had emerged as a major rival to Galveston. The long pier at center is the Morgan Line pier. (LOC.)

On October 16, 1856, the Morgan Line steamship *Perseverance* caught fire while loading hides and cotton at the Morgan Line wharf at Indianola. The fire in the hold proved unmanageable, and the ship burned to the waterline and sank. The wreck of a ship to the right of the Morgan line Pier in the 1860 painting of Indianola (shown in detail) is believed to be *Perseverance*. (LOC.)

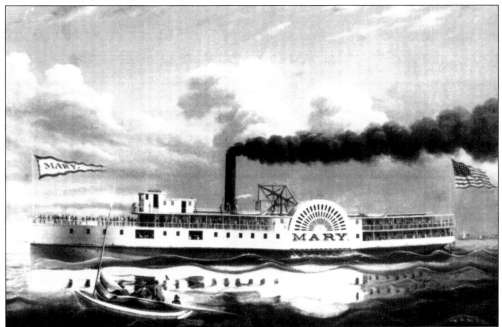

The steamship *Mary*, shown here in happier days, was another Morgan Line ship wrecked in Texas waters. On November 30, 1876, while attempting the narrow channel leading to Corpus Christi, *Mary* struck a buoy and began taking water. Unable to control the leak, *Mary* ran aground and was wrecked. (History Museum of Mobile.)

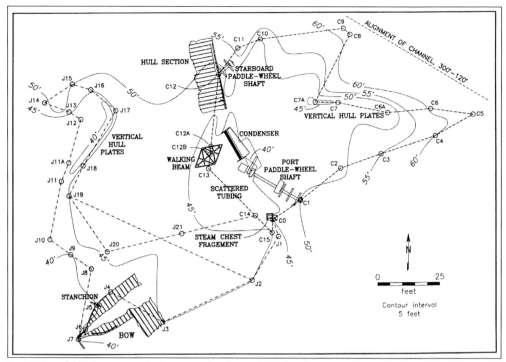

In 1991 and 1993, as part of a larger archeological study of Aransas Pass, the *Mary* remains were examined. This drawing shows the ship's wreckage, scattered by years of dredging and storms, as they exist today near the main ship channel leading to Corpus Christi. (USACOE.)

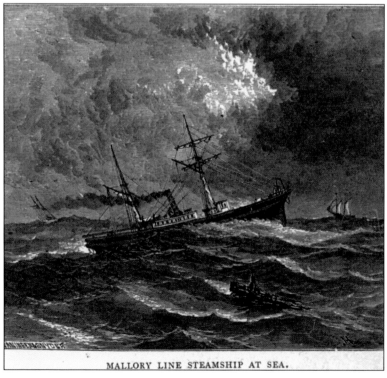

The Mallory Line was the other major shipping line serving Texas, especially Galveston. It lost at least as many ships as the Morgan Line, but since its ships traveled between Texas and the Atlantic coast, relatively few of the Mallory Line wrecks are in Texas waters. (AC.)

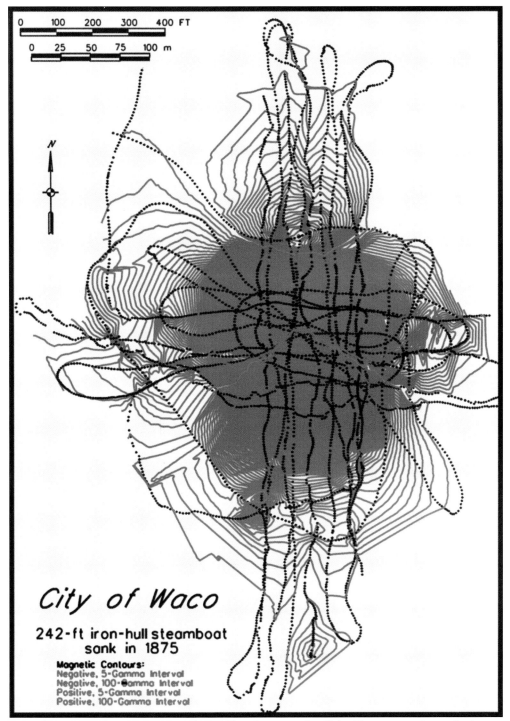

City of Waco was the most spectacular Mallory Line wreck off the Texas coast. It caught fire on November 8, 1875, just after arriving at Galveston Island. Stormy weather made it impossible to enter the harbor, and it sank one mile south of Galveston. In 2004, the wreck was rediscovered. This magnetic-contour map of the site was made shortly afterward. (BOEM.)

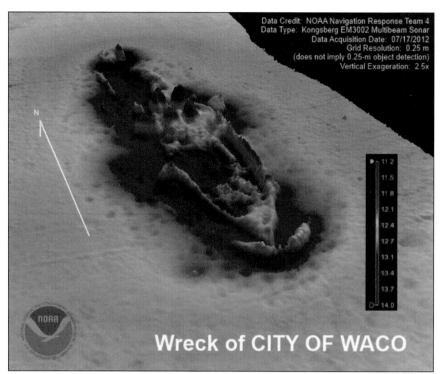

The weather preventing *City of Waco* from entering Galveston's harbor also prevented rescuers from assisting the ship, and 56 people died. In 2011, NOAA conducted a high-resolution survey of the wreck, yielding this image generated by side-scan sonar. The ship's hull can be plainly seen. The four humps amidships are the engines and boilers. (NOAA.)

By 1900, Galveston was the busiest port in Texas. This photograph, taken shortly before the 1900 storm, shows ships docked on Galveston's waterfront, sometimes two deep. (AC.)

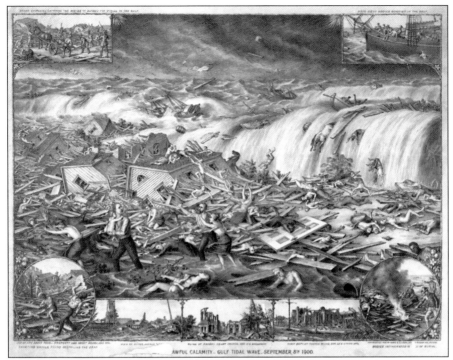

On September 8, 1900, a hurricane swept over Galveston Island. The storm surge swamped the island, albeit less dramatically than the tsunami-type wave shown in this print sold after the hurricane. Rather, it lifted houses off their foundations and ships out of their moorings. (LOC.)

When the waves receded, over 5,000 people were dead. The waterfront was in ruins. These are ships on Pier 20, between where the Texas Seaport Museum and Ocean Star Offshore Drilling Rig and Museum are today. One ship was covered with debris, while a second was on its beam ends. (AC.)

At Pier 23, where cruise ships dock in the 21st century, the ship berthed there at the start of the hurricane was overturned by the storm and left wrecked. (AC.)

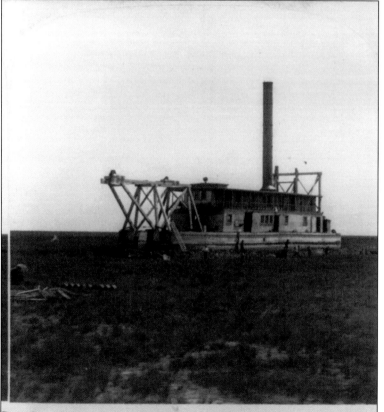

Dredge Boat, driven eleven miles, and stranded three miles from the Sea—Galveston Disaster. Copyright 1900 by Underwood & Underwood.

The waters carried some ships miles inland, leaving them stranded as the water receded back to the Gulf of Mexico. This vessel, normally used to dredge ship channels, was carried 11 miles inland and stranded three miles from the coast. (LOC.)

Six

Texas River Wrecks

1830–1900

Another often overlooked source of Texas shipwrecks are Texas rivers. For seven decades, Texas's rivers were arteries for commerce. Before the railroad and the internal-combustion engine, oxcarts or boats were the only way to get goods to market.

The steam engine arrived commercially in the 1830s, when Texas began getting settled. The river system allowed steamboats to reach the interior. At first, in the 1830s, railroads could not compete with river steamboats. No tracks were laid, and locomotives were neither powerful nor reliable. The Trinity River served the Piney Woods. The central Gulf coast plains used the Brazos River and Buffalo Bayou. The Rio Grande was the highway in the south, and the Sabine and Neches Rivers filled that function in East Texas. The Red River and its tributaries, including Caddo Lake, were commercial conduits in the northeast. Liberty, Jefferson, Magnolia, West Columbia, and Jonesborough came into existence as river ports, growing and shrinking with Texas's river traffic.

Texas rivers proved imperfect highways: shallow, narrow, and hazard-filled. Lightly-built shallow-draft boats were needed to carry reasonable amounts of cargo in the depth of water traveled. Snags—sunken logs—were present in every river and could rip the bottom of a lightly built riverboat. Water levels changed unexpectedly and significantly. A channel navigable on the passage out might be a shoal on the return trip. The boats themselves were hazardous, filled with incendiary materials and flammable cargos, using steam engines that exploded or caught fire.

Yet from the 1830s through the 1870s, there were no real alternatives. Steamboats traveled the Texas rivers despite the risks. The Trinity contains at least 45 steamboat wrecks. The Brazos River is littered with over 19 wrecks. Similar numbers can be found on the Neches, Sabine, and Red Rivers.

Eventually, the railroad displaced the steamboat. By the Civil War, only a few steamboats still plied the Brazos. Trinity River and Caddo Lake navigation petered out in the late 1870s, while the Sabine and Neches were used through the 19th century. The surviving steamboats were abandoned—many left to sink at their moorings.

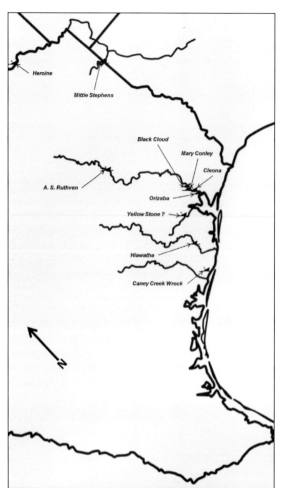

Between 1830 and 1900, Texas rivers served as the arteries for commerce, carrying cotton, hides, and other agricultural products for export, and manufactured goods to rural Texas. (AC.)

The steamboat *Yellow Stone* was one of the earliest Texas river steamboats, arriving in 1835. It is best known for ferrying the Texan army across the flooded Brazos River during the Texas War of Independence. This model of *Yellow Stone* is in the Velasco Museum. (AC.)

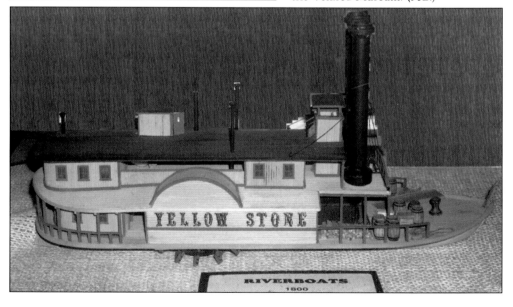

Yellow Stone steamed the Brazos River and Buffalo Bayou. It disappeared after 1837 and is believed to have sunk after hitting a snag in the Brazos River. (AC.)

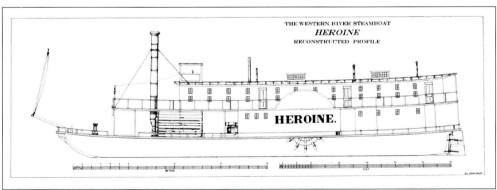

Another early steamboat in Texas was *Heroine*, a boat that plied the Red River between 1832 and 1838. It made regular stops at Jonesborough, the town where Davy Crockett entered Texas on his way to the Alamo in 1836. In 1838, while steaming to Fort Towson with supplies for the Indian Territory, *Heroine* hit a snag and sank. (Kevin Crisman.)

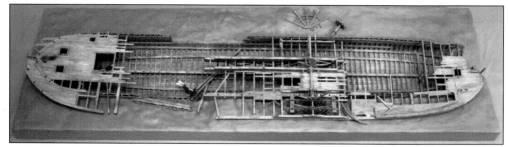

Technically, *Heroine* is an Oklahoma shipwreck, since the Red River up to the Texas riverbank is part of Oklahoma. But since *Heroine* often visited Texas, and sank less than a mile from Texas, it is considered part of Texas's riverboat history. This model made by INA professor Glenn Greico shows the ship's appearance when it was excavated in the 21st century. (Glenn Greico.)

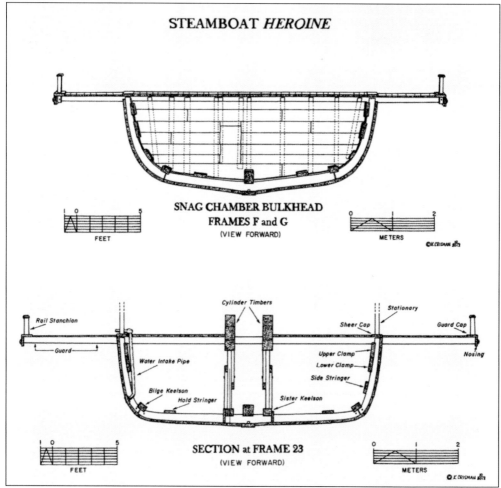

The excavation of *Heroine* revealed a wealth of information about early steamboats. Prof. Kevin Crisman of Texas A&M's Institute of Nautical Archeology was able to reconstruct the ship in detail. These drawing show two transverse cross-sections of *Heroine*—forward, near the collision bulkhead (top) and amidships (bottom). (Kevin Crisman.)

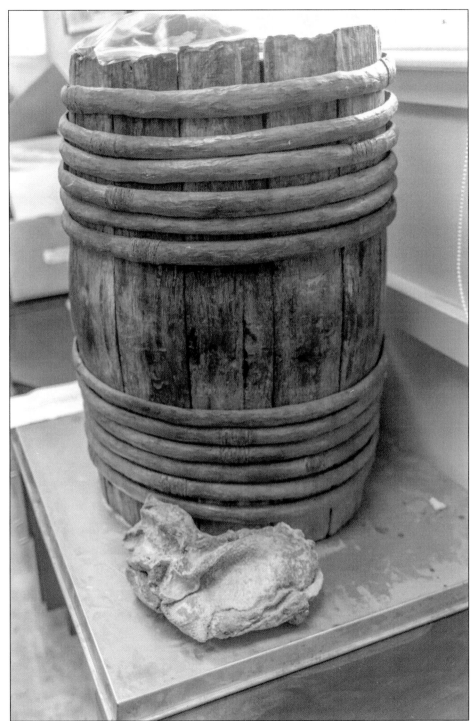

Heroine is the earliest Western steamboat subject to systematic study. It yielded a wealth of information on life in the 1830s, too. This barrel was part of *Heroine*'s cargo. It was filled with salt pork, a piece of which can be seen next to the barrel. In 160 years, it had transformed into adipocere, a soap-like material. (WL.)

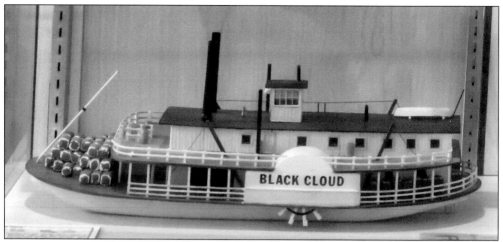

Black Cloud was a Trinity River steamboat during the 1860s and 1870s. It struck a snag at Green's Ferry near the Atascosito Road to Liberty, Texas, in 1873 and was abandoned. (WL, SHRL&RC.)

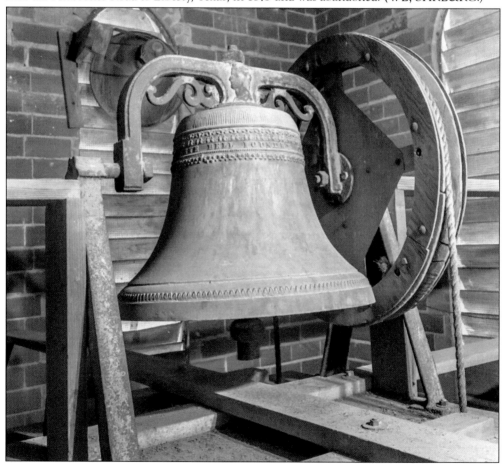

One of *Black Cloud*'s owners removed its bell and donated it to the First United Methodist Church of Liberty. The bell, shown here in the church bell tower, is still used, having outlasted four church buildings. (WL.)

Black Cloud was rediscovered during the installation of a gas pipeline across the Trinity River in 1965. In 1978, students from Texas A&M's nautical archeology program excavated the wreck to learn more about the vessel. Among the artifacts excavated was this object—part of the steam engine drive beam. (WL, SHRL&RC.)

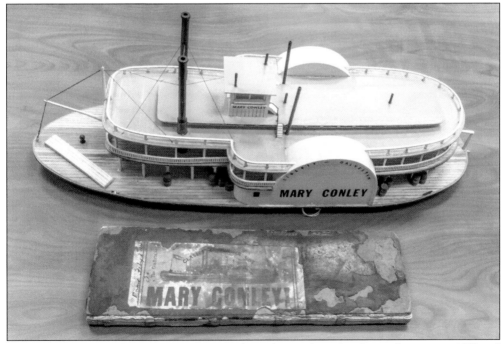

Mary Conley was another Trinity River steamboat during the 1870s. It struck a snag in 1873 and sank. This model depicts *Mary Conley* during its glory days. Next to it is one of the logbooks. (WL, SHRL&RC.)

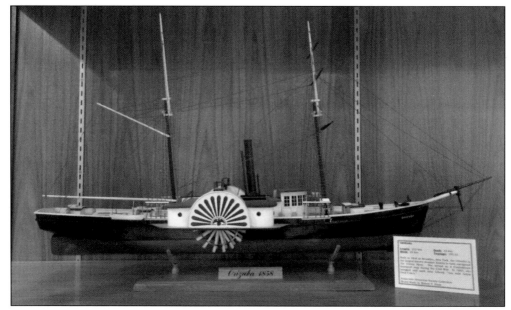

The largest steamboat to regularly travel the Trinity was *Orizaba*, 212 feet long with a 29-foot beam. At 600 tons displacement, it was too big to steam upstream of Liberty. It was lost after it stranded in the lower Trinity River on June 15, 1865. (SHRL&RC.)

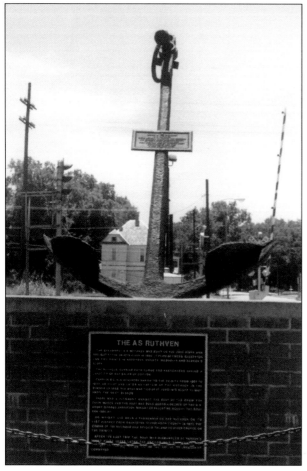

The Trinity River was navigable up to Anderson County, nearly 200 miles from Galveston Bay. A.S. *Ruthven* was abandoned at Magnolia, Texas, in the late 1880s, when railroads made Trinity River steamboats unprofitable. It sank at its moorings, abandoned until archeologists studied it in the 1970s. Among the artifacts recovered was the anchor, now on display in Palestine, Texas, a monument to Texas steamboating. (AC.)

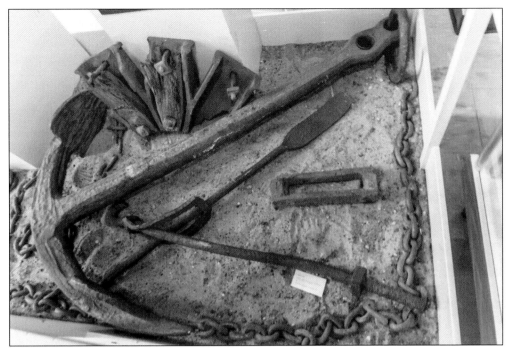

Pictured here is a display of steamboat artifacts in the Sam Houston Regional Library and Research Center in Liberty. The anchor came from the steamboat *Cleona*. The remaining objects—anchor chain, timber fragments, fire brick, wrench, pulley, and paddlewheel flange—came from *Black Cloud*. (WL, SHRL&RC.)

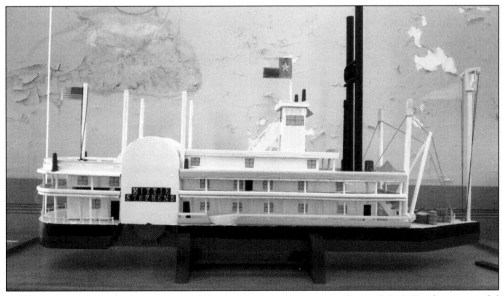

Caddo Lake was another important 19th-century water route into Texas. *Mittie Stephens*, a model of which is shown here, was one of the steamboats regularly calling at Jefferson between 1866 and 1869. (Jefferson Historical Museum.)

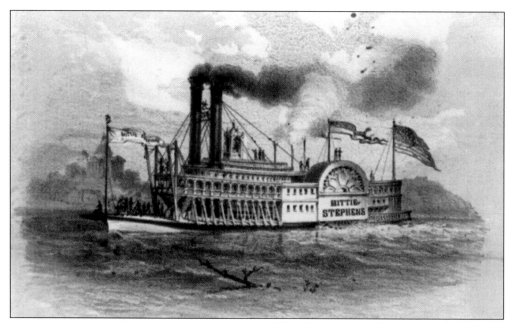

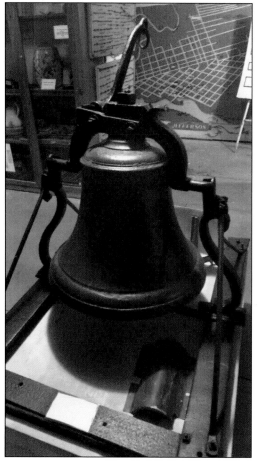

Mittie Stephens was famous enough to have a march composed in its honor. Unfortunately, on February 12, 1869, while traveling at night in Caddo Lake, a spark from a fire basket used to light the way flew back onto the boat, setting fire to hay stored on the ship's deck. (LOC.)

Within minutes, *Mittie Stephens* was ablaze. Before it could reach shore, it ran aground. Of the 107 passengers aboard, 61 perished in the flames or in the water. It burned to the waterline in Caddo Lake. The bell was salvaged and kept as a monument to the disaster. It is on display at the Jefferson Historical Museum. (Jefferson Historical Museum.)

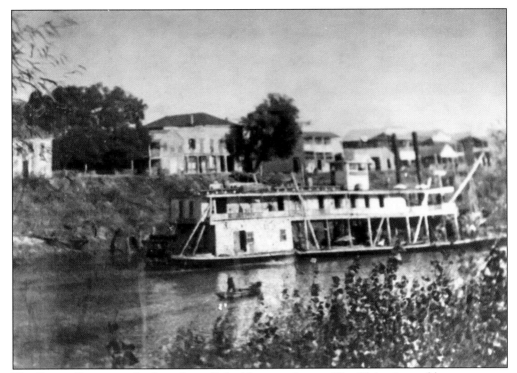

The Brazos River was also heavily trafficked by steamboats. *Alice Blair*, pictured here, was one. Brought from the Mississippi, it carried cotton on the Brazos until 1895. When the boll weevil destroyed the cotton crop, *Alice Blair* was abandoned, tied up on the Brazos River where it eventually sank. (Columbia Museum.)

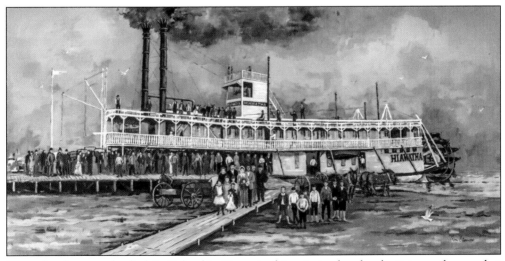

Hiawatha, shown at the dock in Columbia, Texas, in this painting by a local artist, was the grandest Brazos riverboat. In 1895, *Hiawatha* tied up at Columbia with the Brazos in full flood. As the water level dropped, it was discovered *Hiawatha* had moored over a tree stump. *Hiawatha* settled onto the stump, breaking the ship's bottom. It could not be repaired. (WL, Columbia Museum.)

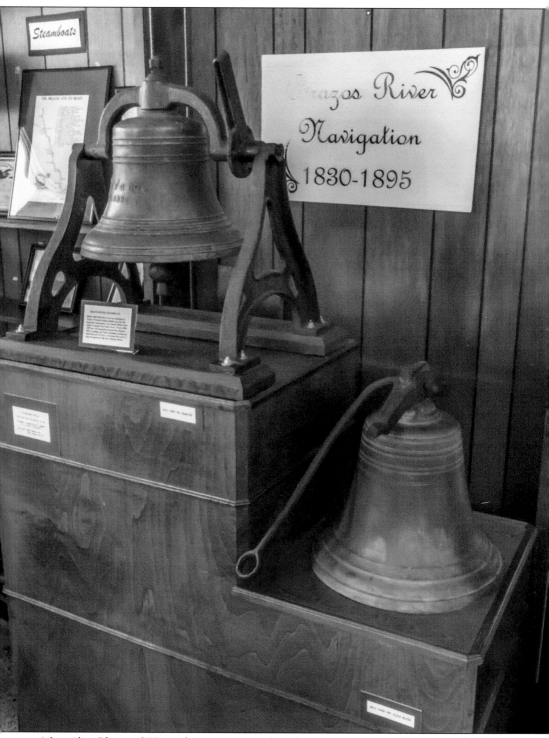

After *Alice Blair* and *Hiawatha* were scrapped, each ship's bell found its way into the Columbia Museum, where they are displayed today. *Hiawatha*'s bell is on the left and *Alice Blair*'s is on the right. (WL, Columbia Museum.)

Seven

THROUGH TWO WORLD WARS

1901–1949

The first half of the 20th century saw two world wars. They had a surprisingly light touch on Texas in regards to shipwrecks. The only warship lost in Texas waters—in World War I or World War II—was USS *Elizabeth* (SP-1092), an 18-ton pleasure yacht. Purchased by the Navy in 1917 and used as a patrol boat, SP-1092 was a victim of the sea, not warfare. It wrecked at the mouth of the Brazos River on November 15, 1918, four days after World War I ended.

While many ships sailing from Texas were sunk during World War II, most were lost well away from Texas—frequently south of the mouth of the Mississippi River. Only three ships were torpedoed near Texas. The tanker *Moria* sunk in the Gulf, off Corpus Christi, the merchantman *San Blas* sunk just north of the Rio Grande River's mouth, and *Oaxaca*, a small cargo ship, was torpedoed off Pass Cavallo.

The most explosive loss occurred immediately after World War II. In 1947, a cargo ship loading ammonium nitrate fertilizer caught fire in Texas City. It exploded, setting fire to a second ship that also exploded. The explosions wrecked and sank a third cargo ship and several barges. It must have seemed as if World War II had briefly returned.

Hurricanes and simple accidents created a crop of shipwrecks in Texas waters. A 1912 hurricane drove *Nicaragua* ashore after the ship lost its rudder. A 1915 hurricane that swept over Galveston left a slew of ships stranded in its wake. As for accidents? Representative of the ships wrecked by accidents were the scow schooner *Lake Austin* and the tanker SS *Selma*. *Lake Austin* missed stays when coming about and got stranded. *Selma* knocked a hole in its concrete hull hitting a dock too hard. When its owners discovered no one could patch the concrete, they abandoned the ship at Galveston.

Both ships became landmarks. *Lake Austin* was excavated and briefly displayed on the beach in the 1970s before being burned as a traffic hazard. *Selma*, still sitting where it sank, is known as Galveston's "concrete ship."

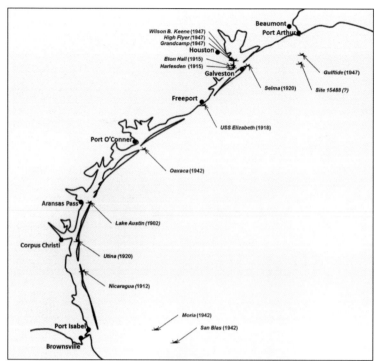

War and weather caused most of the shipwrecks off Texas between 1901 and 1950, although manmade disasters, like the Texas City Disaster, and accidents contributed to the total. This map shows shipwrecks that occurred during this period. (AC.)

On November 19, 1902, the scow schooner *Lake Austin* missed stays while trying to cross the bar near Port Aransas, ran aground, and was wrecked. Sand soon buried the wreck, but in 1966 it was excavated and put on display. It was the only existing example of a Gulf-coast scow schooner, a class shown in this drawing. Unfortunately, interest in the boat waned, and it was burned as a traffic hazard (LOC.)

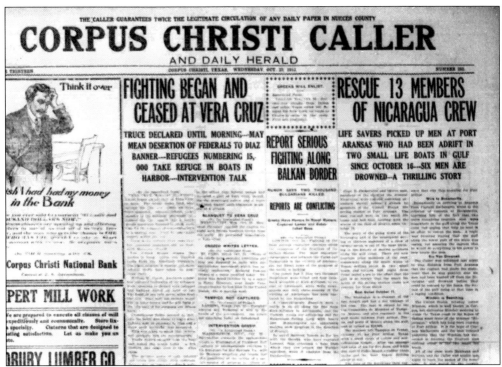

Nicaragua was a small coastal steamer built in 1891 and used for coastal trade. It was the first ship to dock at Port Arthur when the port opened. While steaming from Tampico to Port Arthur in 1912 with a cargo of cotton, it was caught in a storm and forced ashore at the Devil's Elbow on Padre Island. A dozen members of the crew escaped in a lifeboat. Half drowned. Six days later, on October 22, the survivors found safety. (LOC)

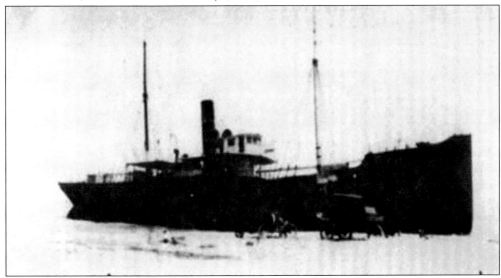

The wreck soon attracted sightseers. This photograph shows *Nicaragua* in 1913, with two carloads of curious onlookers. Subsequent storms and time have demolished much of the ship. Today, only a few rusty ribs and the three cylinders from its triple-expansion steam engine remain. (National Park Service.)

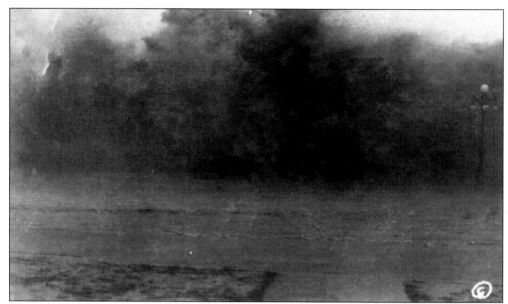

In 1915, a Category 4 hurricane struck Galveston Island. This time, the city was protected by a newly completed seawall. Despite being larger than the 1900 storm and even though the city was inundated by a 21-foot storm surge, there were only 11 fatalities in the city of Galveston. This photograph of the seawall was taken at the height of the storm. (UHDL.)

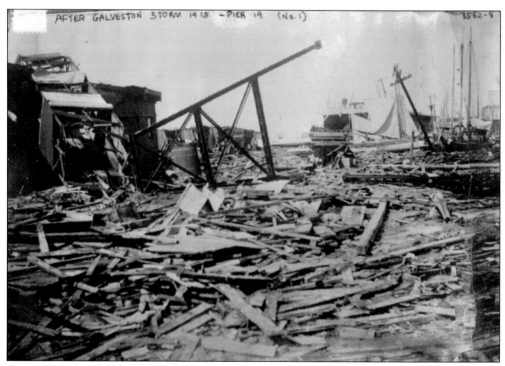

As in 1900, the 1915 hurricane left Galveston's waterfront a mess. Damaged ships can be seen in the background of this photograph of Pier 19, taken in the aftermath of the 1915 hurricane. (LOC.)

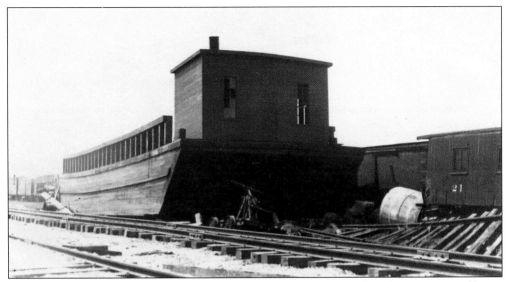

The storm surge also carried many ships far inland. This Clinchfield Fuel Company coal barge came to grief on the railroad tracks at the Santa Fe Railroad's Texas City Junction. A second Clinchfield Fuel Company coal barge ended up in a field beyond the rail yard. (UHDL.)

The British-flagged steamship *Harlesden* was another victim of the 1915 hurricane. It broke its moorings during the storm and was carried inland. When the waters receded, it was stranded between Virginia Point and Texas City. The ship was later scrapped. (UHDL.)

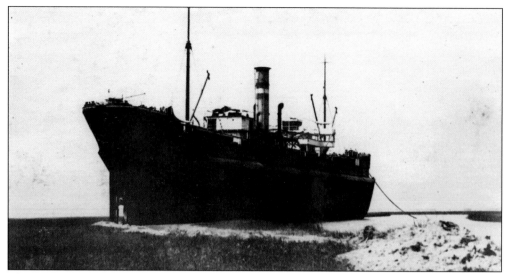

The *Eton Hall* was another British-flagged ship stranded by the receding storm surge. Its crew probably thought the ship was safe, docked far from the war zones of World War I. It too ended on the mainland mud near Swan Lake in Galveston County. (UHDL.)

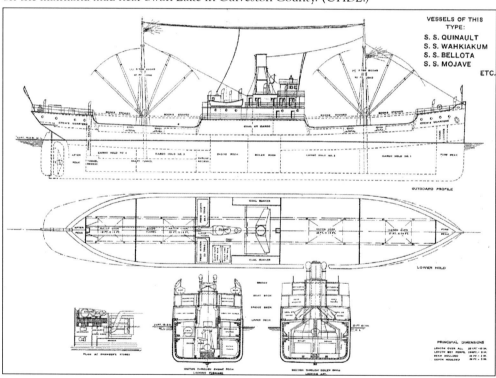

When the United States entered World War I, the government created the Emergency Fleet Corporation to build new ships, both as replacements for ships sunk and to expand the size of the merchant marine. To save metal, the corporation chartered construction of over 300 wooden-hulled steamships, many to the Ferris design shown here. At war's end, these ships were unneeded. Many of the 40-plus ships built in Texas were moored in the Neches River, abandoned, and sunk. (Jan Cocatre-Zilgien.)

Utina, a Ferris-type ship built in Morgan City, Louisiana, lacked engines at war's end. Converted to a bulk-oil barge, it was under tow at Aransas Pass in February 1920 when a strong northeaster pushed it onto the south jetty, where it sank. In 1991 and 1993, its remains were found during an archaeological survey of Aransas Pass. These were a collection of box-like metal objects, most likely fuel or water tanks. (USACOE.)

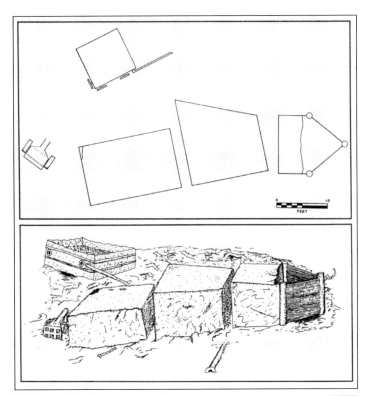

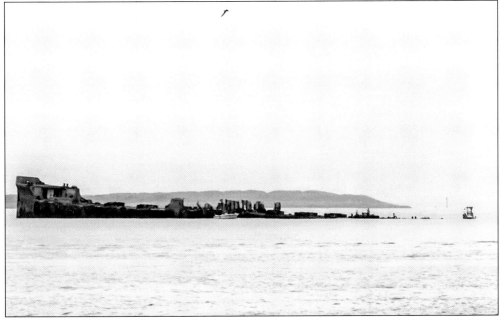

The Emergency Fleet Corporation also had 14 concrete-hull tankers built, including SS *Selma*. Completed too late for the war, it was sold to a commercial oil shipper. A hole in the hull proved impossible to patch, so the owners abandoned *Selma*. To prevent it from becoming a navigation hazard, the Coast Guard beached *Selma* near Pelican Island. It has remained there since 1920, Galveston's "concrete ship." (WL.)

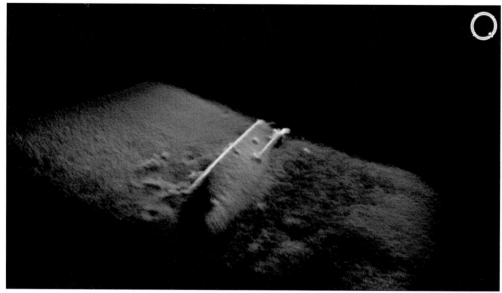

Known only as Site 15488, this shipwreck was found during a geophysical survey done in December 2001. While unidentified as yet, echoscope imagery reveals it as a 20th-century vessel. It may be one of the following ships, which sank in the immediate area: *Frances H.* (1909), *Lydia* (1909), *Doris* (1915), *Emma Harvey* (1916), or *Shamrock* (1939). (BOEM.)

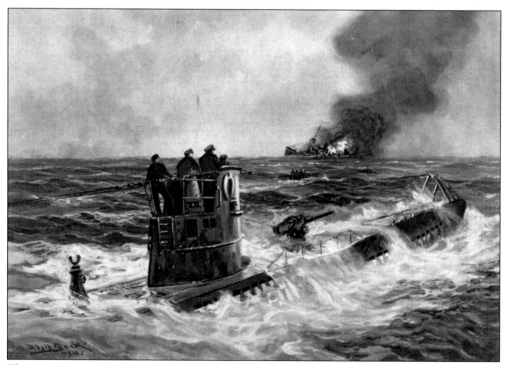

The major menace to shipping in the Gulf of Mexico during World War II was the U-boat. Nazi Germany sent 25 U-boats to the Gulf in 1942 and 1943. They sank 70 merchant vessels during that time. Most were tankers. (LOC.)

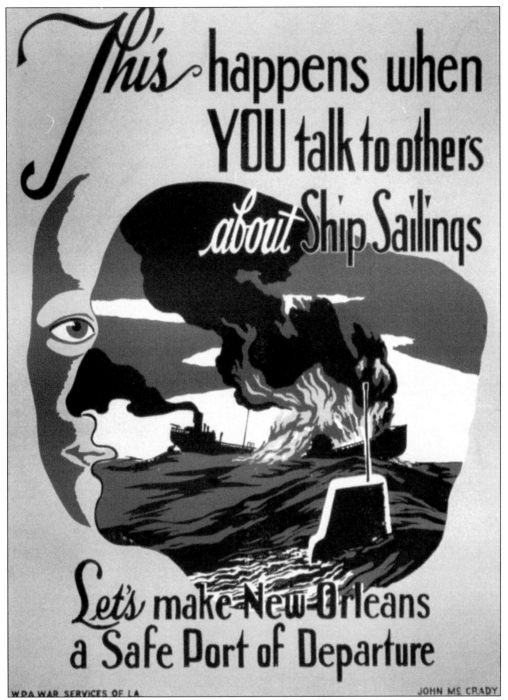

The real U-boat action was off the Louisiana coast, near the mouth of the Mississippi, where tanker sinkings regularly occurred. Sinking occurred so regularly the government printed posters urging silence about ships sailing from New Orleans. (LOC.)

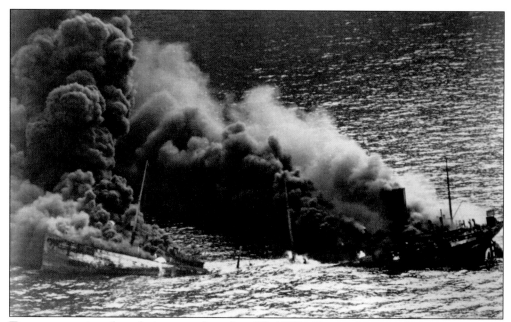

Texas was a major oil-producing state, but when World War II started, most refineries were on the Atlantic coast. That meant Texas crude had to be shipped from ports like Houston, Baytown, Beaumont, and Port Arthur in tankers, only to have the tankers torpedoed and sunk on the voyage outbound. (National Archives.)

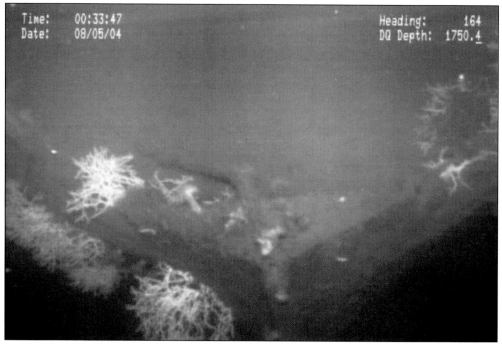

In May 1942, *Gulfpenn* sailed from Port Arthur, Texas, laden with 90,000 barrels of gasoline. On May 13, near the mouth of the Mississippi, it was torpedoed and sunk by U-506. This photograph shows the bow of *Gulfpenn* in 2004 during an archeological survey of World War II shipwrecks. (BOEM.)

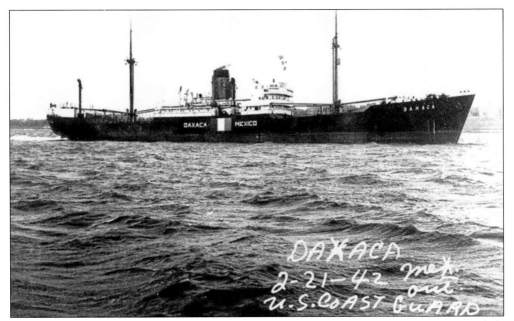

Only one ship was sunk in Texas coastal waters during World War II. On July 26, 1942, while sailing unescorted, SS *Oaxaca* was torpedoed off Pass Cavallo by *U-171*. Six in its crew of 45 died. Mexico was neutral when this photograph was taken, hence the Mexican flag on the side. (Peter DeForest and Henry Wolff Jr.)

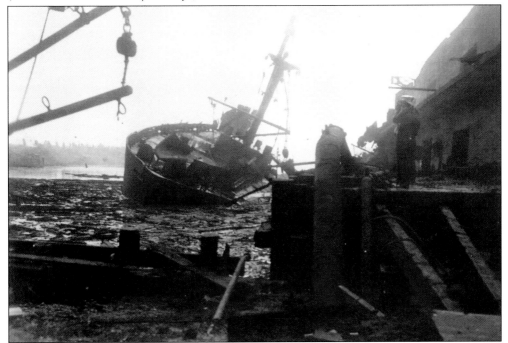

On April 16, 1947, *Grandcamp*, a French ship loading a cargo of fertilizer at the Texas City docks, caught fire and then exploded, destroying the docks and a nearby chemical plant and setting other ships ablaze. Debris from the explosion set fire to *High Flyer*, another ship loading fertilizer. It too exploded, sinking the SS *Wilson B. Keen* (pictured). (UHDL.)

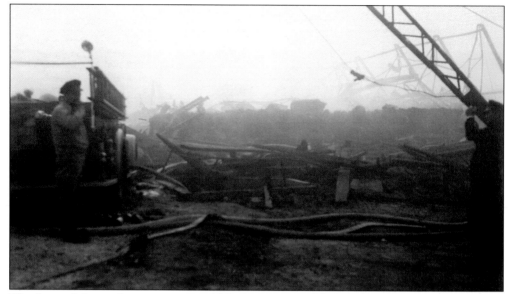

The force of the explosions was incredible. It was powerful enough to lift a barge in the slip adjacent to *Grandcamp* out of the water and drop it on shore. The barge, pictured, is recognizable only by its frames. The explosions killed at least 581 people, including every member but one of the Texas City Fire Department. (UHDL.)

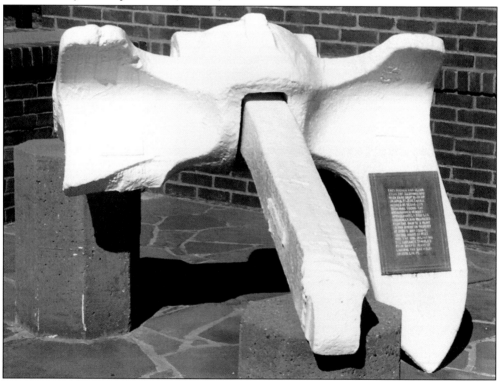

Grandcamp's anchor and *High Flyer*'s propeller were flung over a mile inland by the explosions. Both were preserved as memorials to the tragedy. Today, *Grandcamp*'s anchor, one fluke broken off when it hit the ground 1.6 miles away, is now in Texas City's Memorial Park. (AC.)

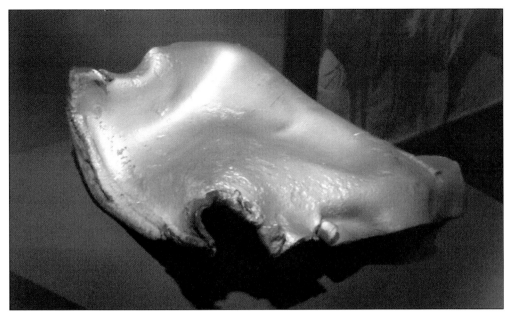

Other artifacts from the disaster, including this fragment of the hull of the *Wilson B. Keene*, are preserved in the Texas City Museum. (AC.)

Gulf Tide was a cutterhead-type pipeline dredge that sank September 28, 1947, in 50 feet of water about 13 miles southeast of the Sabine Bank Light. It was similar in appearance to YM-09 (pictured here), a dredge used by the US Navy. (US Government.)

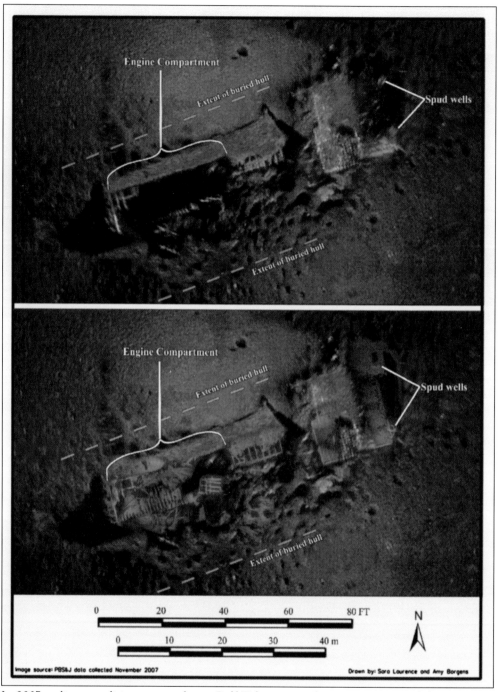

In 2007, a dive expedition was made on *Gulf Tide* as part of an investigation of the impact of hurricanes on submerged wrecks. These side-scan sonar data and acoustic underwater camera images of *Gulf Tide* were made to support the study. (BOEM.)

Eight

To the Present
1950–2015

Since World War II, no wars have troubled Texas waters. The pace of shipwrecks has increased, however. There have been four times as many shipwrecks since 1950 as there were in the entire period before 1950. This does not reflect increased maritime dangers; rather, it testifies to the explosive growth of maritime traffic over the last 70 years. New ports were opened. Houston grew into the nation's second-largest seaport. The offshore oil industry was born during this time, requiring a vast number of crew and service boats to operate the offshore wells. Commercial fishing increased. The number of pleasure craft using the Texas coast and Gulf of Mexico exploded.

Meanwhile, the hazards of the sea remain, as do the shallow coastal waters and shifting shoals. Hurricanes regularly lash the Texas coast, each one leaving a tally of wrecks in their wake. Sometimes storms do not have to be a hurricane. Any severe weather can put a ship in peril, especially if combined with grounding.

Added to this is the hazard associated with shipping volatile petroleum or chemical products. Thanks to Texas's sandy sea bottom, no *Torrey Canyon* or *Exxon Valdez*–scale oil spills have occurred, although collisions have created smaller spills. But several tankers have exploded when sparks ignited petroleum vapor in empty tanks. Notable among these are *V.A. Fogg* and *OMI Charger*.

Another new source of shipwrecks off the Texas coast are ships sunk deliberately, to create maritime habitats. Since 1950, the Texas Parks and Wildlife Department (TPWD) has created over 25 artificial reefs in Texas waters using obsolete ships donated for the purpose. In the 1970s, a dozen old Liberty ships were sunk at five different sites in the Gulf. Since then, several World War II–era tankers and the former Texas A&M school ship *Texas Clipper* have been used as reefs. Divers are encouraged to visit these sites to explore and fish.

Few modern wrecks are considered historical. Many can be salvaged and removed. Some have been, especially those posing navigation hazards. These ships may not be treasure ships of legend, but they still hold interesting stories.

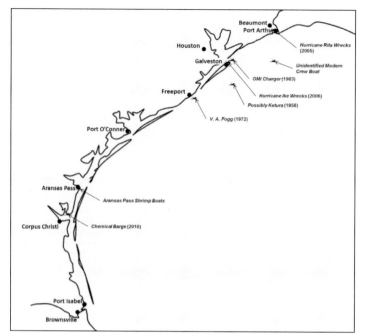

This is a map of Texas shipwrecks from 1950 to the present. This map does not list all shipwrecks over that period but rather shipwrecks discussed in or of interest to this chapter. (AC.)

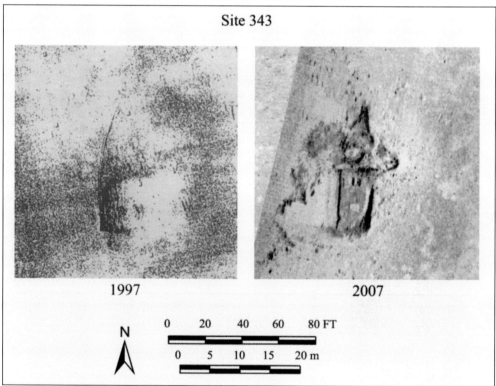

These are sonar scans of a sunken vessel south of High Island, Texas. Sonar scans of the sea bottom to determine the presence of wrecks prior to drilling or laying a pipeline are routine today. This determines whether a historically significant wreck is present. This wreck, known as Site 343, is not of historic significance. It is believed to be a modern crew boat. (BOEM.)

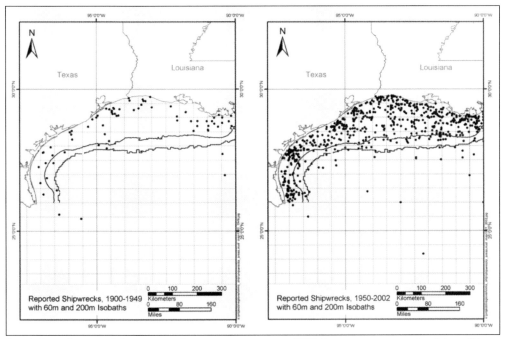

Site 343 marks one of the many sinkings occurring since 1950 due in part to growth of the offshore oil industry. These two maps show the dramatic increase in shipwrecks over the last 50 years, mainly due to the explosive growth in the number of ships using Texas waters. (BOEM.)

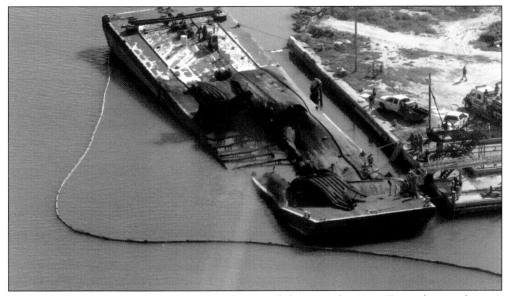

Texas's petrochemical industry has created some of the most dramatic Texas shipwrecks over the last 70 years. Volatile gases in a confined space can lead to explosive situations. This barge exploded at Superior Docks in Ingleside, Texas, on March 25, 2010. (US Coast Guard.)

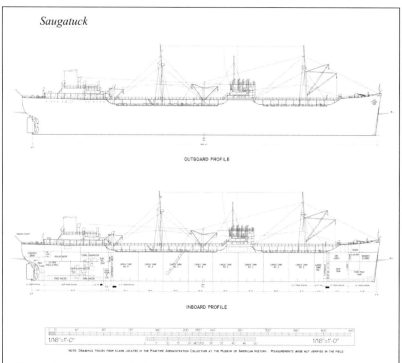

The V.A. *Fogg* began its career in World War II as the *Four Lakes*. Launched in 1943, it was one of many war-emergency T2-SE-A1 tankers built to replace tankers sunk by enemy action. Its appearance was similar to SS *Sagatuk*, shown in this drawing. (LOC.)

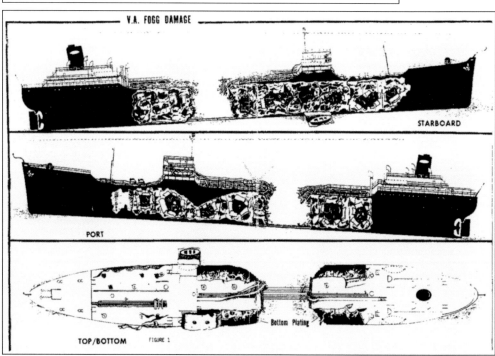

In 1971, *Four Lakes* was sold to new owners and renamed *V.A. Fogg*. On February 1, 1972, it left Freeport, Texas, for Galveston. While cleaning its tanks to remove residual benzene, it exploded and sank, killing all aboard. The official Coast Guard report included this drawing illustrating the damage suffered. (USCG.)

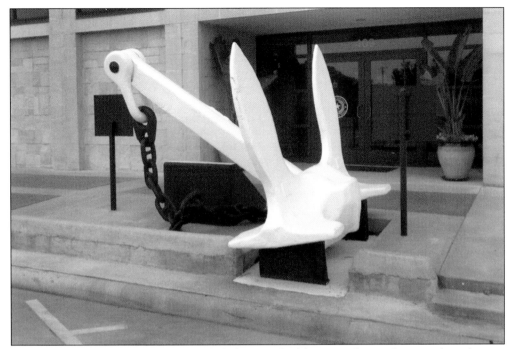

The Coast Guard investigation revealed the crew had been inadequately trained in clearing benzene fumes. An electric spark from a blower lowered into the hold by the crew for ventilation is believed to have caused the explosion. The V.A. *Fogg*'s anchor was later recovered. It stands as a monument to the crew at the Texas City Museum. (AC.)

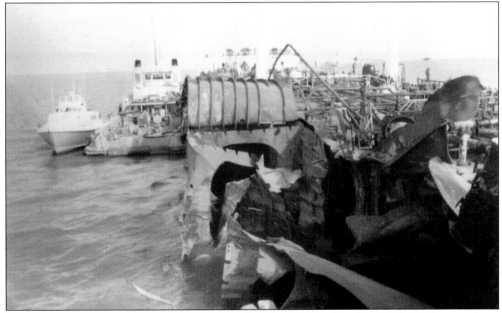

A similar fate overtook *OMI Charger* while anchored in Bolivar Roads in 1983. Workers patching a leak inside a tank with an arc welder set off gasoline vapor remaining in the tank, which had been insufficiently ventilated. The explosion killed three, injured seven, and triggered a fire destroying the ship. (Carey Akin.)

UNITED STATES COAST GUARD

INVESTIGATION INTO THE CIRCUMSTANCES SURROUNDING THE EXPLOSION AND FIRE ABOARD THE TANKSHIP

OMI CHARGER

ON OCTOBER 9, 1993, AT BOLIVER ROADS INNER ANCHORAGE NEAR GALVESTON, TEXAS, WITH INJURIES AND MULTIPLE LOSS OF LIFE

After a lengthy investigation, the Coast Guard report on the accident issued several recommendations to prevent reoccurrence of this type of accident. These emphasized the importance of training and the need to avoid cutting corners when venting tanks filled with volatile gasses. The report also commended the crews of three ships that assisted *OMI Charger* after the explosion. (USCG.)

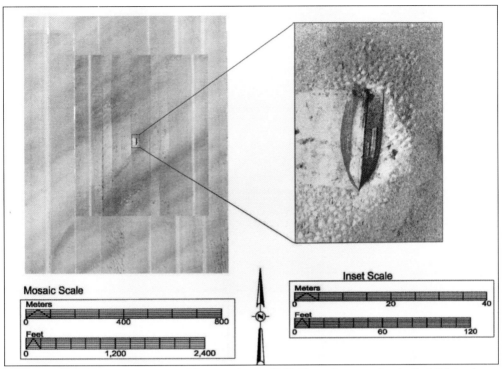

Hurricanes remain a major cause of shipwrecks. In 1957, *Keturah*, a wooden-hulled fishing boat, experienced engine problems. As Hurricane Audrey approached, the Coast Guard attempted a rescue, but hurricane conditions blew *Keturah* against an oil platform, sinking it. A Coast Guard cutter present was unable to save its crew. This side-scan sonar image made in 2003 may be *Keturah*. (BOEM.)

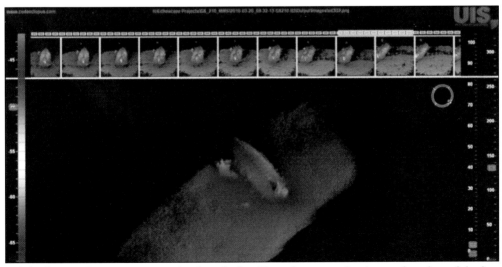

While the wreck was not positively identified as *Keturah*, its size closely matches that of the lost fishing vessel. This echoscope image made in 2010 clearly shows the outline of the hull. Another possibility is the *William Hayes*, a fishing vessel that sank in July 1957. (BOEM.)

A dive was made on the site in 2010. It gave other clues, including this protrusion, likely a nozzle, often seen on fishing boats. The scale is 10 centimeters, with markings every two centimeters. However, since the other possible candidates are also fishing vessels, identification cannot be made positively. (BOEM.)

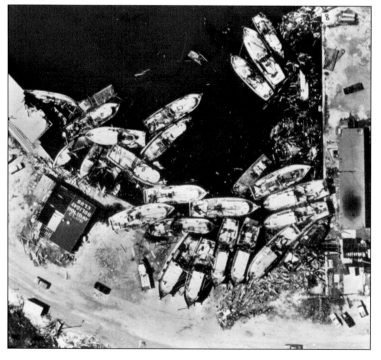

Hurricanes often leave large numbers of wrecks in their wake. Following Hurricane Celia in 1970, most of the shrimp fleet in Aransas Pass ended up grounded in the harbor. This aerial photograph shows them clustered near the Holiday Club. (NOAA.)

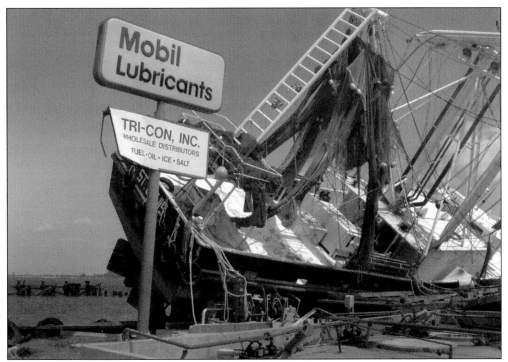

In 2005, Hurricane Rita struck the mouth of the Sabine River. After it left, this shrimp boat was stranded on a fuel dock at Port Arthur, Texas. (NOAA.)

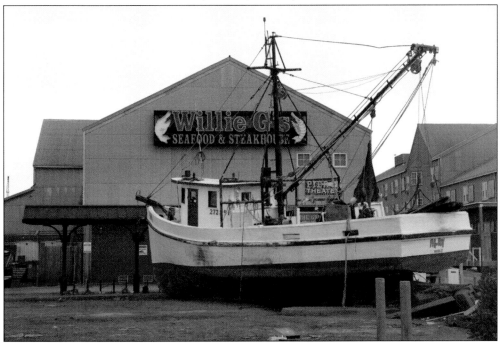

Willie G's is a Galveston waterfront restaurant noted for fine dining. Hurricane Ike inundated most of Galveston Island in 2006. When the waters receded, this fishing boat was in the parking lot behind Willie G's, high and dry. (NOAA.)

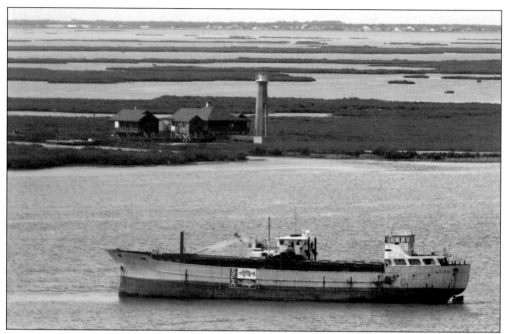

The Texas Parks and Wildlife Department has a program to repurpose large marine vessels as artificial reefs. The reefs serve as habitats for saltwater fish and destinations for sport divers. Here, 155-foot *Kinta S* is being towed past the Lydia Ann lighthouse near Aransas Pass en route to becoming a new reef. (Photograph by Earl Nottingham, TPWD.)

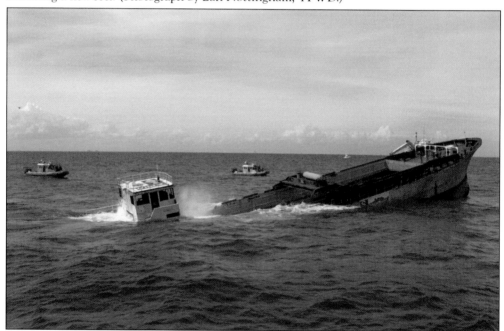

Kinta S sinks in 75 feet of water near Corpus Christi, Texas, in 2014, enhancing the Corpus Christi Nearshore Reef. *Kinta S* outlived its usefulness as a freighter but now has a new use. TPWD encourages exploration of these reefs—these are Texas shipwrecks people can visit. (Photograph by Earl Nottingham, TPWD.)

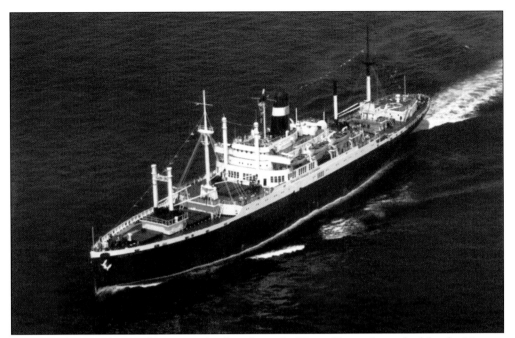

The most famous ship used as an artificial reef was the *Texas Clipper*. Launched for the Navy as USS *Queens* during World War II, the ship spent 30 years as US Training Ship *Texas Clipper*, the school ship for the Texas Maritime Academy at Texas A&M University at Galveston. It was retired in 1996. (Texas A&M University-Galveston.)

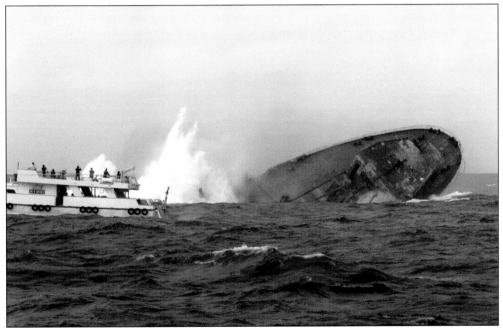

After being retired, *Texas Clipper* was turned over to the TPWD for conversion into a reef ship. After being cleaned to remove toxic and hazardous materials and prepared for sinking, *Texas Clipper* was towed to a spot 17 nautical miles northeast of South Padre Island and sunk. (Photograph by Earl Nottingham, TPWD.)

This map shows some of the artificial reefs created by the Ships-to-Reefs program. For more information on reef locations, contact the TPWD. (TPWD.)

Nine

EXPLORING TEXAS SHIPWRECKS

MARINE ARCHAEOLOGY IN TEXAS

The real treasure in ships lies not in the gold and silver aboard but in the historical information preserved within, but how is that information extracted? It is done through the time-consuming and meticulous process of marine archaeology. A typical effort lasts years, including the research conducted before the actual visit to the site and the analysis afterward. The search for the location of *la Belle*'s wreck started in 1977, but restoration of the ship's remains was completed only in 2015. And the research and conservation of finds continues.

Fortunately, Texas possesses one of the world's leading research centers for marine archaeology, the Institute for Nautical Archaeology at Texas A&M University. Located at Texas A&M's College Station Campus, 150 miles from the Gulf coast, it conducts underwater archaeology throughout the world and has a Texas-sized reputation all over the globe. Dives have taken them to the Kinneret Sea, the Japanese coast, and Port Royal, Jamaica.

Texas waters and rivers remain favorite exploration areas for the staff. When a lightning exploration is needed, such as the recent look at the USS *Westfield* before deepening the Texas City Ship Channel destroyed the remnants, Texas A&M is at hand. Additionally, Texas shipwrecks offer close opportunities for marine archeology students to practice their craft.

What does it take to explore a shipwreck? This chapter will start from the discovery of a wreck. The process often begins with a survey by a company planning to drill an offshore lease or build a structure crossing a river. Or it can result from shipwreck artifacts being revealed by abnormally low water or a chance find by a visitor.

From there? It depends on what is found. More often than not, it traces the pattern shown here: survey, exploration, excavation, preservation, conservation and restoration, analysis, and finally—if preservationists get lucky—display in a museum. It is an interesting process.

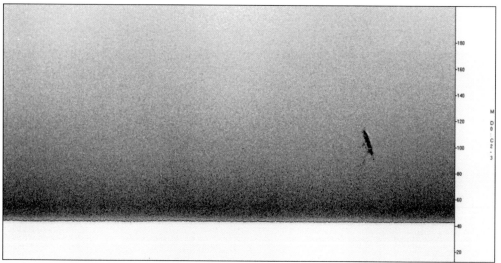

Exploration of Texas shipwrecks begins with the discovery of a wreck. Often, deep-water wrecks are found while conducting ocean-floor scans during oil exploration. This acoustic-sonar image, part of a side-scan sonar survey of the Monterrey lease block in October 2011, revealed one of the three shipwrecks there. (NOAA.)

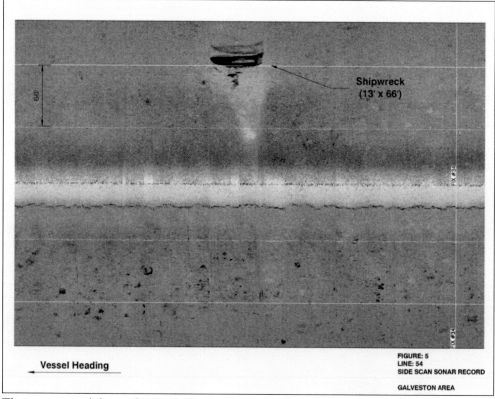

The next step is defining the wreck through more complete survey. This can be done using side-scan sonar, magnetic-resonance, or echoscope imaging. This is the side-scan sonar image of Site 15366, an unidentified modern wreck off Galveston. (BOEM.)

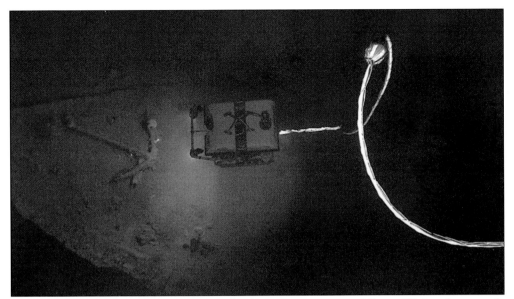

If the wreck is sufficiently interesting, archeological examination follows. With a deep wreck, exploration is done using a remotely operated vehicle such as this one, *Little Hercules*, captured above an anchor from the large Monterrey wreck. (NOAA, Okeanos Explorer Program.)

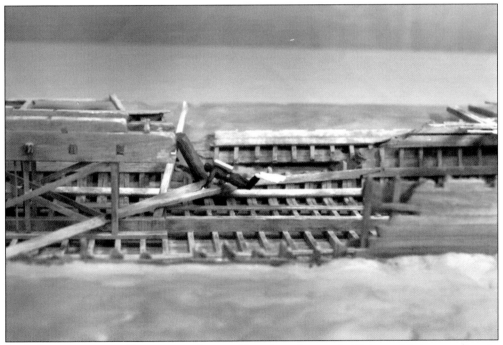

In shallow water or on Texas rivers, divers will explore the wreck. This model shows a diver in the *Heroine*, a steamboat wrecked on the Red River. (Glen Greico.)

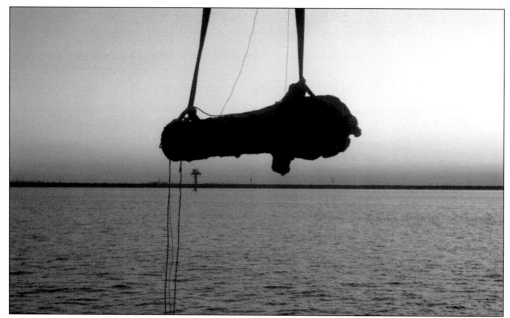

Artifacts with historical value are recovered from a wreck, where they begin the process of conservation and restoration. Objects as small as a glass trade bead or as large as this cannon lifted from Galveston Bay go through this process. (Justin Parkoff.)

Texas is fortunate to have one of the world's finest marine archaeology facilities, the Institute for Nautical Archeology at Texas A&M University in College Station, Texas. It is frequently the next stop for artifacts recovered from the water, whether they come from Texas or the other side of the world. (AC.)

Objects long immersed in water are damaged if exposed to air before being treated. Until they can be, shipwreck finds are stored in water-filled tanks. Holding tanks can be as small and simple as this tub, in which small objects have been sorted into crates and buckets. (WL.)

Holding tanks can also be as large and elaborate as this concrete basin, large enough to hold *la Belle* intact, with a system to raise and lower the timbers of a wreck. If the objects are wood, polyethylene glycol (PEG) is added to the water. PEG replaces water in long-immersed wood, preventing warping or shrinking as it dries. (WL.)

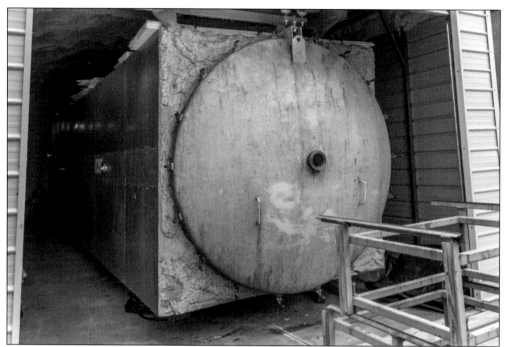

Once soaked with PEG, the wood is freeze-dried to remove any remaining water. The conservation laboratory at Texas A&M has this chamber as large as a truck trailer to freeze-dry wood. It is the largest chamber used for marine archaeology. (WL.)

The freeze-dry chamber can hold the frames of a ship. The wood in this photograph was taken from *la Belle* and is undergoing the final step in its preservation. From here it goes to the Bullock Museum in Austin, Texas, where it will be added to the reassembled ship. (WL.)

Once preservation is complete, restoration can begin. Long-immersed objects, such as these items from the riverboat *Heroine*, are typically covered with concretions, which must be removed. (WL.)

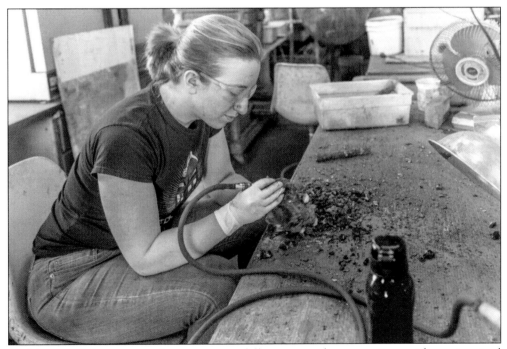

In this step of the process, the restorer carefully removes the concretions with a rotary tool while stopping short of the encased artifact. This is one of the graduate students in the marine archaeology program at A&M. (WL.)

Students go through rigorous training in the art of restoration while studying marine archaeology. How does one learn to reassemble potshards? By painting an everyday garden shop flower pot, smashing it, and reassembling the pieces in a classroom. (WL.)

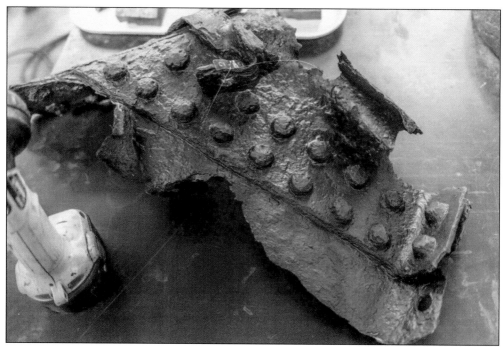
A fully restored artifact is shown here. This is a piece of a boiler from a steamboat. (WL.)

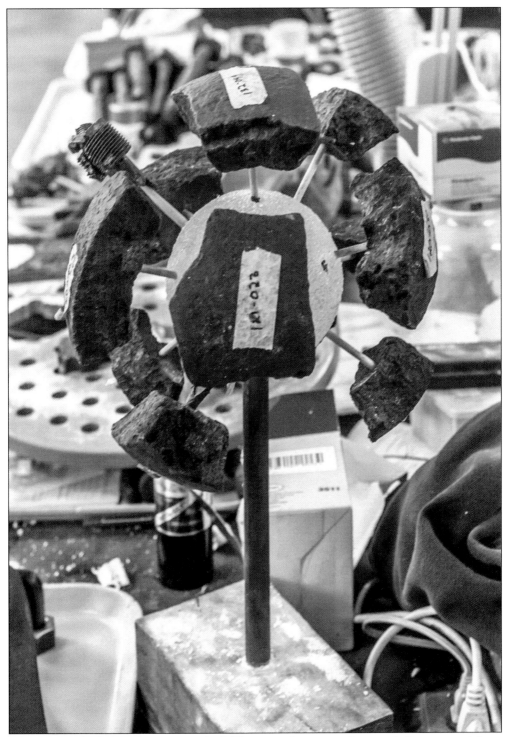

Once restored, the artifacts are studied. These are fragments from a shell, recovered from USS *Westfield*. The archaeologist is attempting to reassemble the pieces to understand what happened. (WL.)

Often, castings are made of objects so resin replicas can be made. This is an example of a mold. Sometimes, the replicas are used in museum displays, often because the metal has disappeared, leaving only the outline of the object in the encasing material. (WL.)

The remnants of actual ships are not the only tools used to understand the past. In this case, an archaeologist is examining an antique model of a ship to compare with fragments of similar vessels found in an archaeological dig. (WL.)

Modern models also aid understanding of historic ships. When this is finished, it will be a model of *Heroine* as the vessel appeared when it was recovered from the Red River, 166 years after it sank. (WL.)

While many artifacts are retained for study, some are sent to museums for display. Some items go to major maritime or historical museums, but many end up in local historical museums, such as this one, the Brazoria County Historical Museum in Angleton, Texas. (AC.)

Museums

Want to see Texas shipwrecks? Check out these museums, all of which contain artifacts:

Brazoria County Historical Museum
(*Acadia* artifacts)
100 East Cedar Street
Angleton, TX 77515
979-864-1208
bchm.org

Bullock Texas State History Museum
(*la Belle*)
1800 Congress Avenue
Austin, TX 78701
512-936-8746
thestoryoftexas.com

Columbia Historical Museum
(Brazos riverboats)
247 East Brazos
West Columbia, TX 77486
979-345-6125
columbiahistoricalmuseum.com

Corpus Christi Museum of Science and History
(1554 wrecks)
1900 North Chaparral Street
Corpus Christi, TX 78401
361-826-4667
ccmuseum.com

Jefferson Historical Museum
(riverboats)
223 West Austin Street
Jefferson, TX 75657
903-665-2775
jeffersonmuseum.com

John E. Conner Museum, Texas A&M University-Kingsville
(1554 wrecks)
905 West Santa Gertrudis Street
Kingsville, TX 78363
361-593-2810
tamuk.edu/artsci/museum

Museum of the Gulf Coast
(riverboats)
700 Procter Street
Port Arthur, TX 77640
409-982-7000
museumofthegulfcoast.org

Old Velasco Museum
(riverboats)
1304 Monument Drive
Surfside Beach, TX 77541
281-866-2604

Texas City Museum
(Texas City Disaster, *V.A. Fogg*, *Westfield*)
409 Sixth Street N
Texas City, TX 77590
409-229-1660
texas-city-tx.org

Texas Seaport Museum
(Texas navy)
2100 Harborside Drive
Galveston, TX 77550
409-763-1877

The Sam Houston Regional Library and Research Center
(Trinity riverboats, Sabine Pass)
650 FM 1011 Road
Liberty, TX 77575
936-336-8821
tsl.texas.gov/shc/index.html

Treasures of the Gulf Museum
(1554 wrecks)
317 East Queen Isabella Boulevard
Port Isabel, TX 78578
956-943-7602
portisabelmuseums.com

BIBLIOGRAPHY

Arnold, J. Barto III, Jennifer L. Goloboy, Andrew W. Hall, and Rebecca A. Hall. *Texas' Liberty Ships, From World War II Working-Class Heroes to Artificial Reefs.* Austin, TX: Texas Historical Commission, 1998.

Arnold, J. Barto III and Robert S. Weddle. *The Nautical Archeology of Padre Island: The Spanish Shipwrecks of 1554.* New York, NY: Academic Press, 1978.

Bass, George F. *Ships and Shipwrecks of the Americas: A History Based on Underwater Archaeology.* New York and London: Thames and Hudson Ltd., 1988.

Bureau of Ocean Energy Management. Gulf of Mexico OCS Region Publications: boem.gov/Gulf-of-Mexico-OCS-Region-Publications/#ARCHAEOLOGY

Catsambis, Alexis, Ben Ford, and Donny L. Hamilton. *The Oxford Handbook of Maritime Archaeology.* New York, NY: Oxford University Press, 2011.

Gaines, W. Craig. *Encyclopedia of Civil War Shipwrecks.* Baton Rouge, LA: Louisiana State University Press, 2008.

Pearson, Charles E. and Joe J. Simmons III. "Underwater Archaeology of the Wreck of the Steamship Mary (41NU252) and Assessment of Seven Anomalies." Baton Rouge, LA: Coastal Environments Inc., 1995.

Texas Historical Commission: thc.state.tx.us/learn/publications

US Coast Guard. Homeport: homeport.uscg.mil/mycg/portal/ep/browse.do?channelId=-18374

Discover Thousands of Local History Books
Featuring Millions of Vintage Images

Arcadia Publishing, the leading local history publisher in the United States, is committed to making history accessible and meaningful through publishing books that celebrate and preserve the heritage of America's people and places.

Find more books like this at
www.arcadiapublishing.com

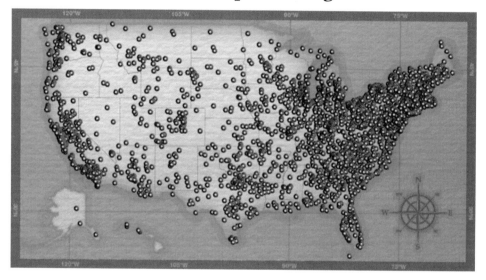

Search for your hometown history, your old stomping grounds, and even your favorite sports team.

Consistent with our mission to preserve history on a local level, this book was printed in South Carolina on American-made paper and manufactured entirely in the United States. Products carrying the accredited Forest Stewardship Council (FSC) label are printed on 100 percent FSC-certified paper.